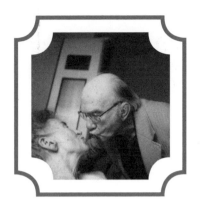

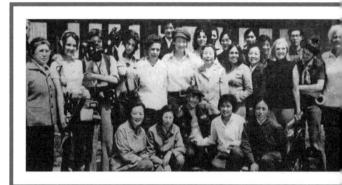

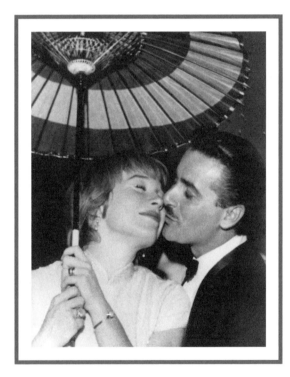

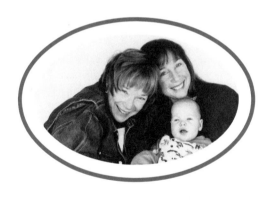

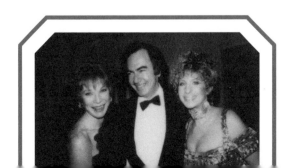

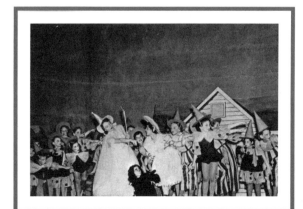

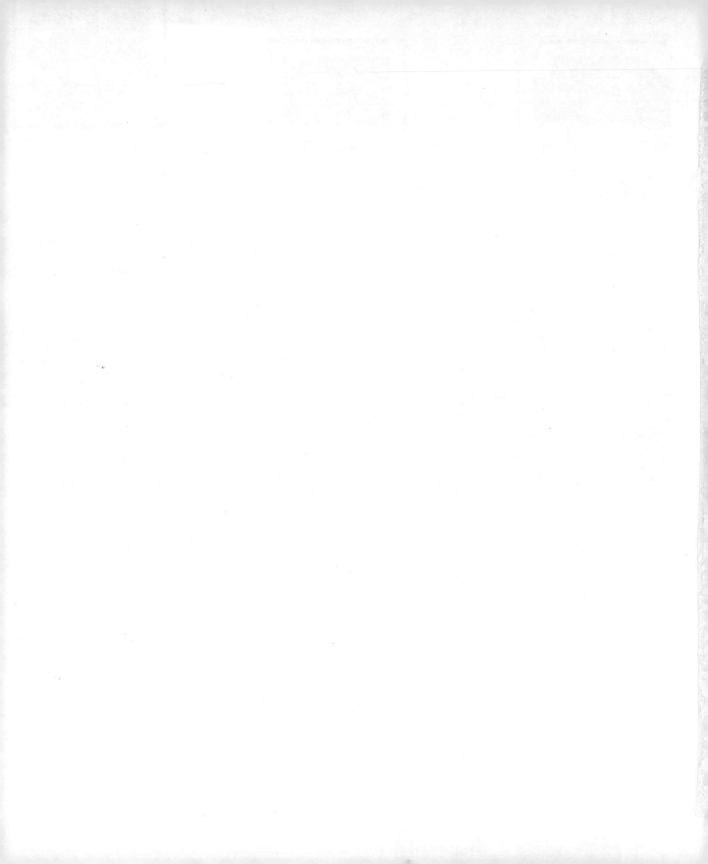

# The Wall *of* Life

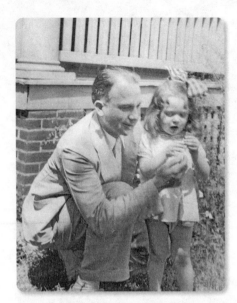
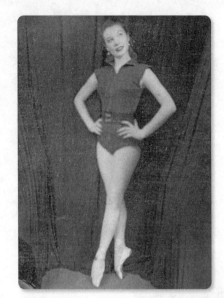
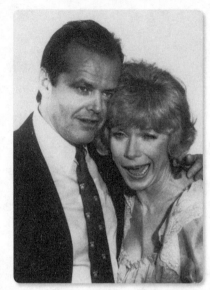
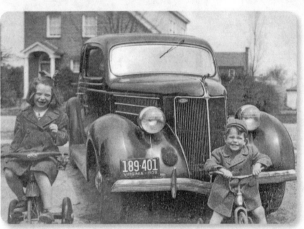
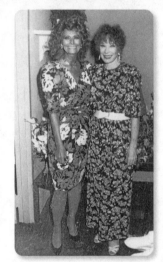
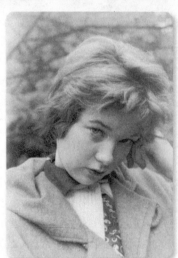

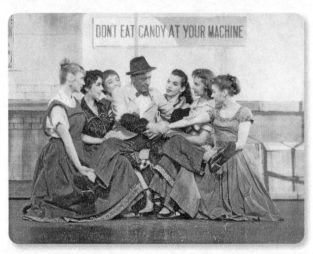

DON'T EAT CANDY AT YOUR MACHINE

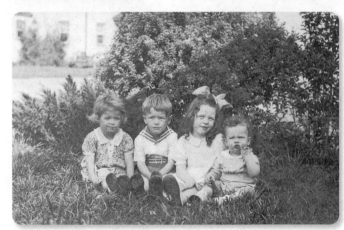

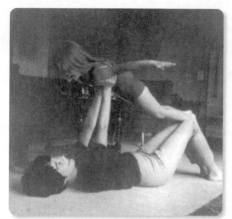
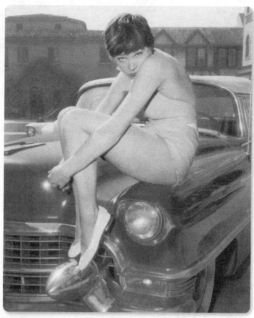
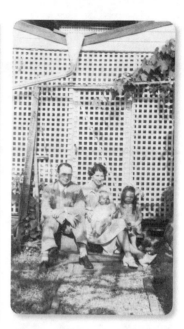
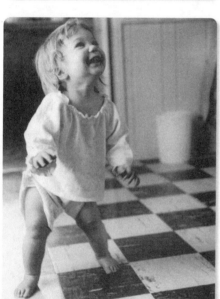
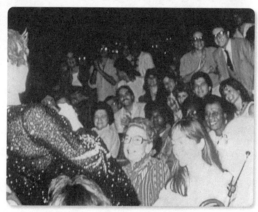
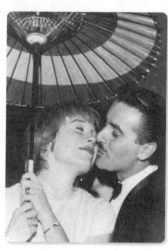
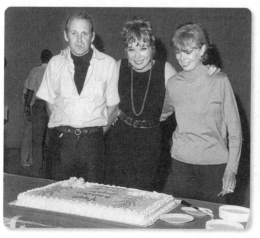

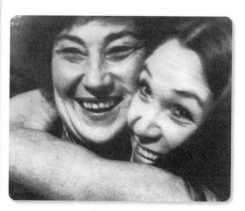

## ALSO BY SHIRLEY MACLAINE

*Don't Fall Off the Mountain*

*McGovern: The Man and His Beliefs*

*You Can Get There from Here*

*Out on a Limb*

*Dancing in the Light*

*It's All in the Playing*

*Going Within*

*Dance While You Can*

*My Lucky Stars*

*The Camino*

*Out on a Leash*

*Sage-ing While Age-ing*

*I'm Over All That*

*What If*

*Above the Line*

# The Wall of Life

Pictures and Stories from This Marvelous Lifetime

## Shirley MacLaine

CROWN

NEW YORK

Published in the United States by Crown, an imprint of the Crown Publishing Group, a division of Penguin Random House LLC, New York.
crownpublishing.com

CROWN and the Crown colophon are registered trademarks of Penguin Random House LLC.

Photograph credits appear on page 245.

Library of Congress Cataloging-in-Publication Data
Names: MacLaine, Shirley, 1934– author. Title: The wall of life: pictures and stories from this marvelous lifetime / Shirley MacLaine. Description: First edition. | New York: Crown, 2024. | Identifiers: LCCN 2024021541 | ISBN 9780593735305 (hardcover) | ISBN 9780593735312 (ebook) Subjects: LCSH: MacLaine, Shirley, 1934– | MacLaine, Shirley, 1934– Pictorial works. | Entertainers—United States—Biography. | LCGFT: Autobiographies. Classification: LCC PN2287.M18 A3 2024 | DDC 791.4302/8092
[B]—dc23/eng/20240618
LC record available at https://lccn.loc.gov/2024021541

Hardcover ISBN 978-0-593-73530-5
Ebook ISBN 978-0-593-73531-2

Printed in the United States of America on acid-free paper

Editor: Matt Inman
Assistant editor: Fariza Hawke
Production editor: Patricia Shaw
Text designer: Andrea Lau
Production managers: Philip Leung and Heather Williamson
Copy editor: Rachelle Mandik
Proofreaders: John Vasile and Lawrence Krauser
Publicist: Mary Moates
Marketer: Chantelle Walker

1st Printing

First Edition

*To Steve*

# CONTENTS

# The Wall *of* Life

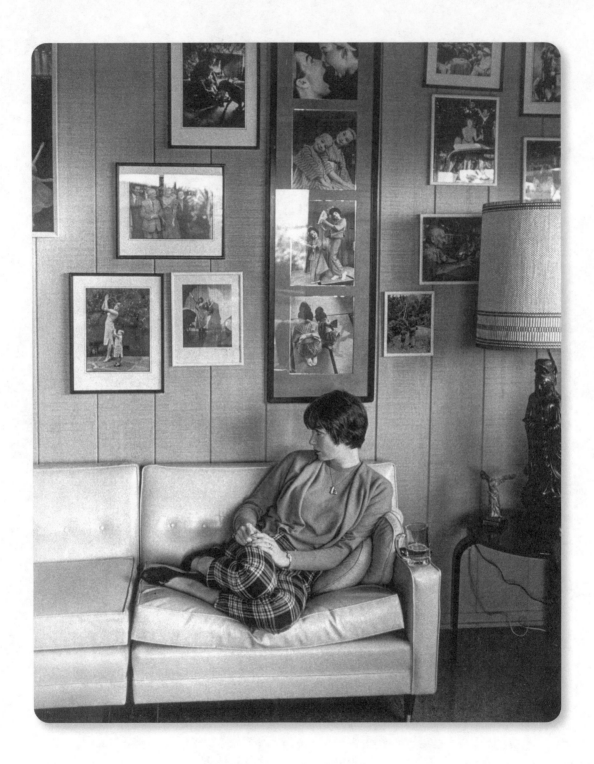

# INTRODUCTION

About forty-five years ago, I put ten or so framed photographs of friends and family and people I've worked with all grouped together on a living room wall in my Malibu home. Everyone who came over loved to look at this montage, and so the "Wall of Life" was born. Over time, I added more until there were scores and scores of images pretty much covering the space, similar to the collection of photographs on the first and last few pages of this book. I even created a Wall of Life at my ranch in the New Mexico mountains and, until fairly recently, there was also a giant one at my home of almost twenty years in Santa Fe. But this collection really wasn't about me as much as it was about all the people around me. In this magical and enchanting life of mine, I've known so many women and men who were interesting—extraordinary, really—and whom I was truly fond of and lucky to know. This wall helps me to remember them and respect them and keep them a part of my life. And there are photographs of people and friends from not only film and television but dance and theater, as well as government and politics, my spiritual journey, and, of course, my family. This is really the only book I've written that includes all the different worlds I've traveled through and been so fascinated by. Today, I am still shocked and surprised when, after looking at the wall, my memories surface and I realize who is still with me and who is not.

The Wall of Life has been a stage for asking questions, and not just for visitors to ask me things, but for me to ask myself to get at a deeper truth, and to ask my visitors to understand them more. I've been reminded that I'm not someone who eagerly engages in small talk and I am known to ask some rather probing questions. Most of the time people are fine with it, and these questions somehow help me know the human race better and understand what is wrong with us. Or what is right with us. Or what is still unknown about who we are. Human identity and human nature are what I love to study, and if nothing else, I want to be remembered for my curiosity and trying to see and know as much as possible. I worry, though, that I haven't done enough, documented enough, or asked enough questions, so for now, I continue to add and subtract pictures on the Wall of Life—it's still an ongoing project.

# Part 1

# *Beginnings*

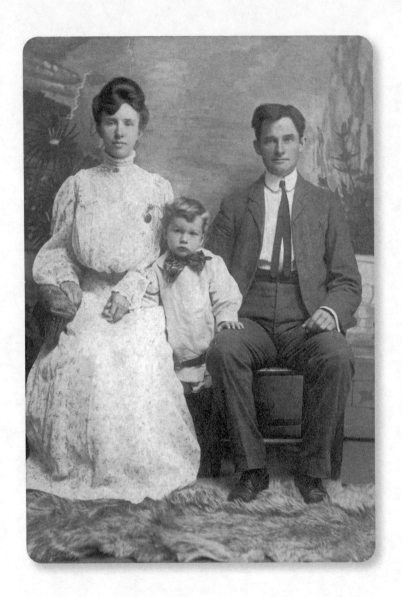

My grandmother Ada with my father, Ira, and my grandfather Wendell.

I love this picture of my grandmother and grandfather with Daddy in between them because it suggests how my past influenced my future. My grandparents lived in a small town in Virginia and were nowhere near show business, but all three of them do seem very natural in front of the camera.

Was Mother dreaming of being a star? I do know that she wanted to be an actress. She was an acting student in Nova Scotia, but she sacrificed furthering her career when she committed to motherhood and wifedom. Every year or so, she did a small-time play and was absent from the house more than my father appreciated. She also taught acting classes in our town at night, and it would upset my dad, but I realized what she was doing and cheered her on. Her acting in little plays helped define my independence and interest in show business. It helped me realize that husbands and fathers can have a problem with the freedom of their wives and children. Mother and Daddy argued but stayed loyal to the marriage.

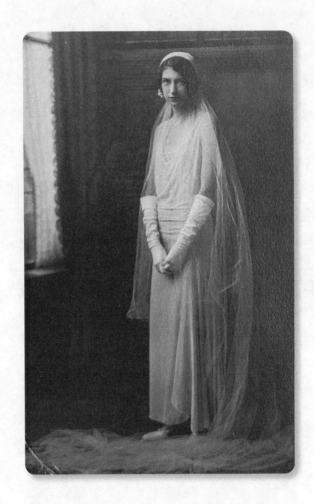

Mother looking beautiful on her wedding day.

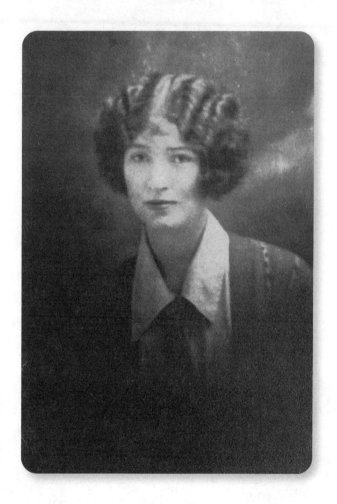

But sometimes she also wore a tie.

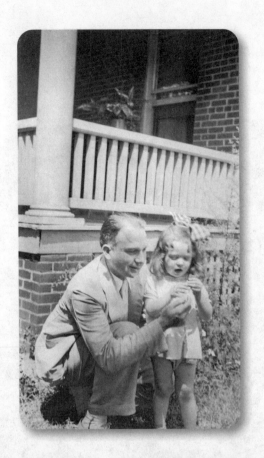

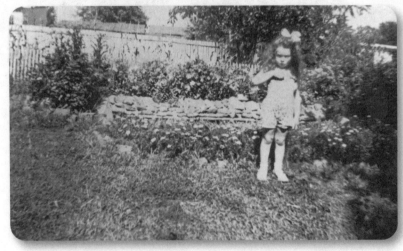

Daddy was a principal and eventually superintendent of schools in Rappahannock County, Virginia. That was a big deal. But he used to go on and on about wanting to run away and join a circus, and how he wanted to get away and be an entertainer. He said it seriously, and knowing him, I believe it. He was also a very good violinist. I played as well for a couple of years, but it wasn't enough for me. In these pictures, I'm around three years old, and it's when I started ballet classes, the beginning of a lifelong passion for dance.

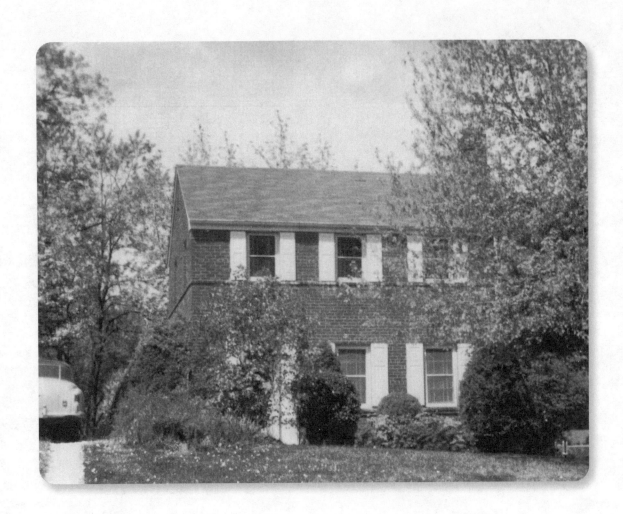

This is our family home at 930 North Liberty Street in Richmond, Virginia. That house guided our lives. Many years after he was born, Warren had a bedroom in it with his own private closet that had a window. It was a place he used to hide and disappear. He could just get away and be anywhere, and I was jealous.

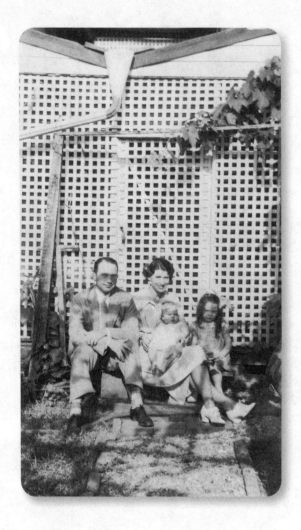

I don't remember much before Warren. (My earliest memory, though, is of having my diapers changed.) I do recall my mother warning me before he was born . . . and "warning" is a good word to describe it. I think that was less about the baby and more about her and her anxiety. She was Canadian, and they just always worry. In this case, I think she was actually worried about whether she would do it right, be the mother she was supposed to. Once Warren arrived, I just wanted to protect him all the time. But in this picture right after he was born, I think my expression might be a little "What about me?"

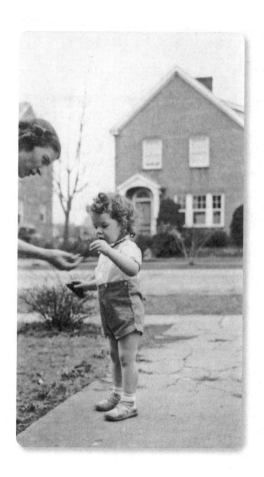

I always loved my curls.

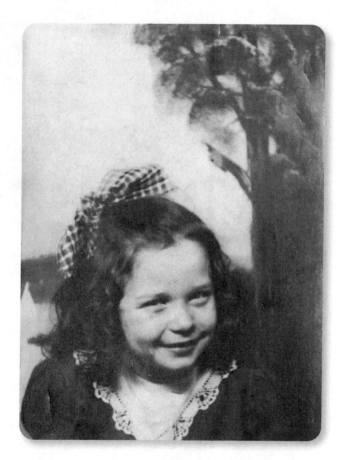

My large red hair with yet another ribbon in it.

Warren at two and our dog Trixie. We quarreled over who loved her the most. (I probably did, because I have a dog with the same name now.)

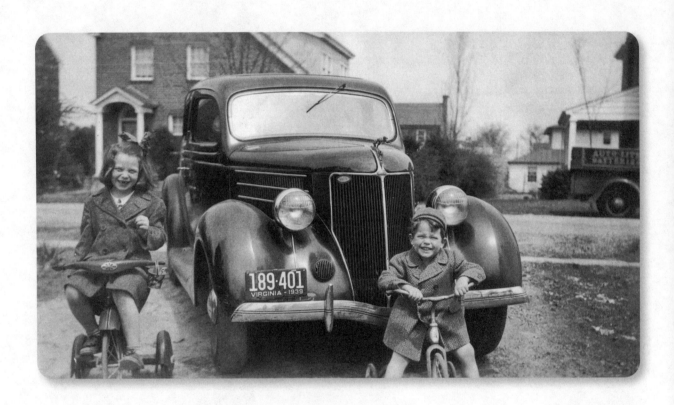

Me, age five, and Warren, age two, in front of our third sibling, or my daddy's favorite child, the Ford.

Playing the big sister.

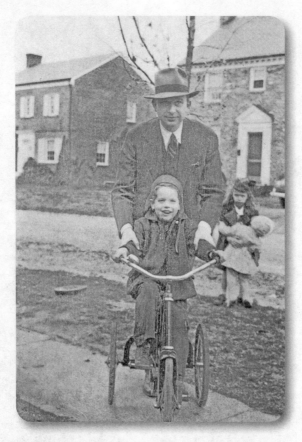

Here's Daddy showing off Warren, age two, on a tricycle with me, age five, in the background holding my doll. I think I gave up dolls after that. If I played with them, my brother would get all the attention, as you can see. But in reality, Mother and Warren had a special connection, and Dad and I had the same thing. I don't know why completely, but I know I admired his intelligence, and he liked having a little girl.

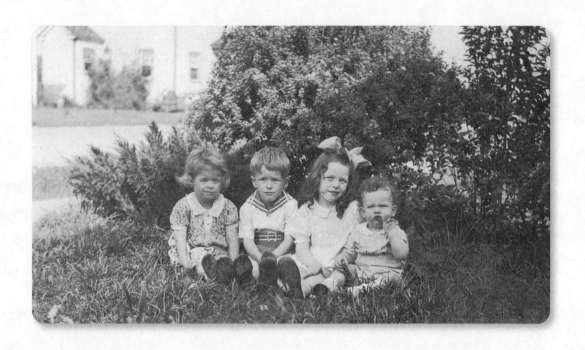

Tommy and Sarah Sidner, our next-door neighbors, with me and Warren.
I really did wear a lot of bows.

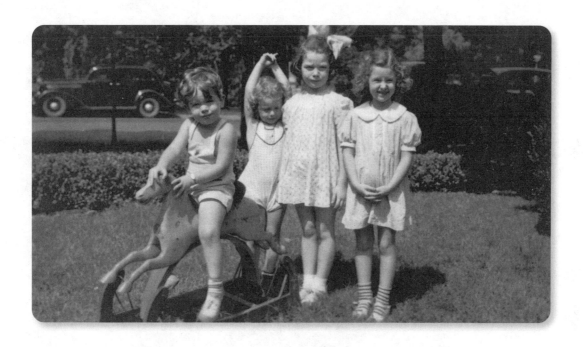

Warren is on the left and I'm between our first cousins, Quincy and Jean.
We were very close to them.

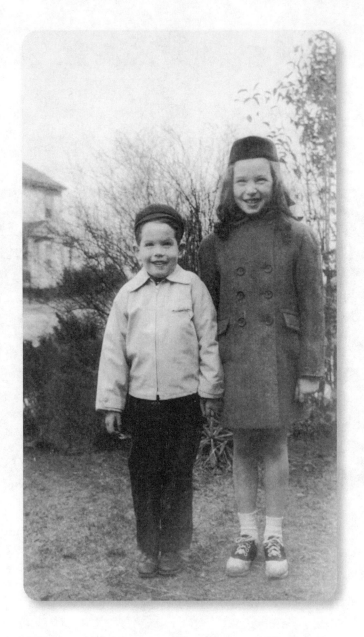

Me at eight and Warren at five. At some point, it seemed like I took over taking care of my brother. I always had to have his hand, which I think Warren kind of resented, because I led him off to different places when Mother was busy.

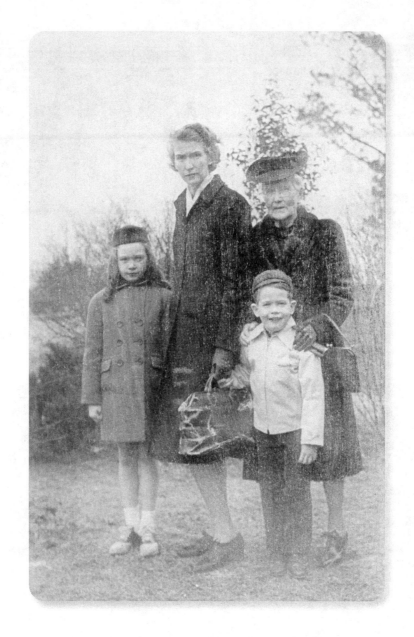

Me, Mother, Grandmother MacLean, and Warren.
A serious moment—at least for the women in the family.

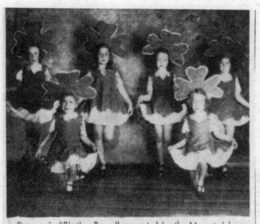

Dancers in "Rhythm Revue" presented by the Margot Johnson School of Dancing at the Westhampton High School on Friday night include those pictured above, left to right: Patsy Page, Alice Parks, Marcia Riggs, Shirley Beatty, Barbara Ford, Libby Thompson.

My first dance recital.

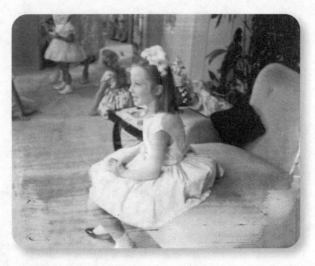

A recital when I was between six and eight years old. I always had something on my head.

My sixteenth dance recital. I'm the fairy godmother.

As I recall my life, I have come to understand that the physicality of dance was the most influential force. From the age of three, I loved the music, discipline, working with others, and basically using "all of me." My parents came to all recitals, and Mother usually sewed all my costumes. I think Daddy loved my interpretation of music because he was a musician.

Lisa Gardener and Mary Day, my dance masters, were the most important teachers I had. They were disciplinarian and free-expressionistic at the same time. They helped me see the meaning in the music of composers and helped me relax with the physical pain of dancing. I will always be grateful for my mother's insistence that I take dance lessons every day, even on the weekends.

Before I was even a teenager, I would ride the bus from 930 North Liberty Street to Georgetown (which was the dope capital of this country then) and transfer to a streetcar to get to the Washington School of Ballet, the dancing school of Miss Gardener and Miss Day. After three hours of dancing, I would return home in the evenings after dark and have to walk through a magical forest because the buses were no longer running. Everyone was asleep when I got home, and that's when I fell in love with peanut butter crackers for dinner.

I can't express really how important Mary Day and Lisa Gardener were. They have always been the biggest influences *in my life* because they also said, "You put too much feeling in your dance, and so you might wanna act." After I made it in show business, I did go back to their school a few times to talk to them. Maybe I've been an influence for other people; it's hard to know what goes on in others' imaginations, but I'm not sure I would want to influence anybody too much and I have probably refrained from it.

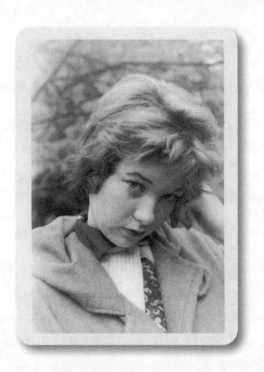
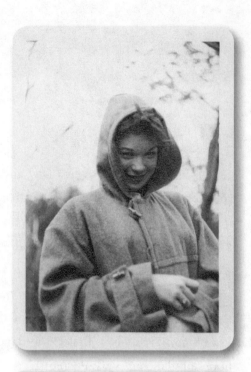
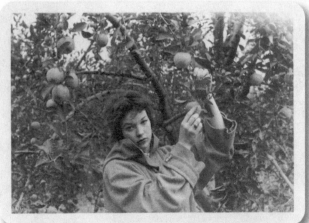
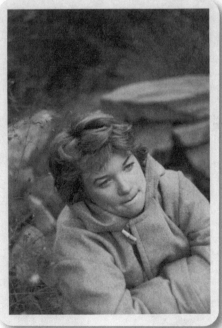

Growing up, it seems I was always at dance class, but I also let the guys be around to play and would throw the football with them; I was actually a bit of a tomboy. I don't know who took these photos, but I don't think it would've been a boyfriend. They seem to reveal that I knew what I wanted to express—different moods, different faces—almost like I'm trying out acting to understand how it feels.

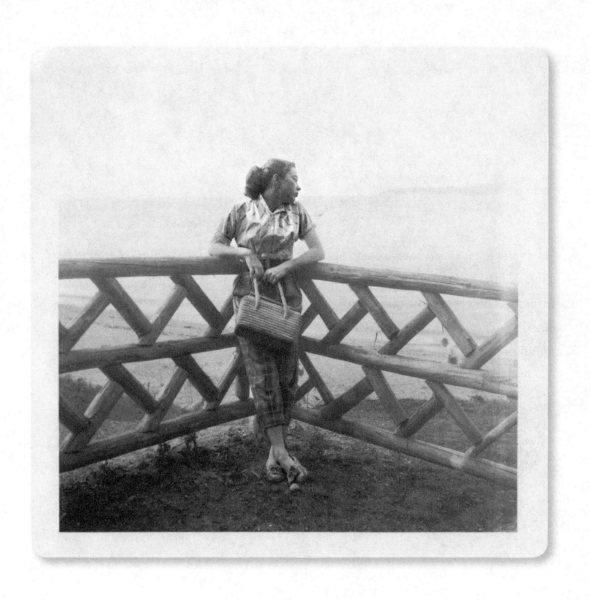

At an early age, probably seven, I knew I wanted to pursue a career as a dancer or performer, so by the time I was in my teens, I was ready to be free of family life and make a move in that direction. Mother was teaching drama to students, but she never took me to a class, and I never got involved with that side of her life. Interesting . . .

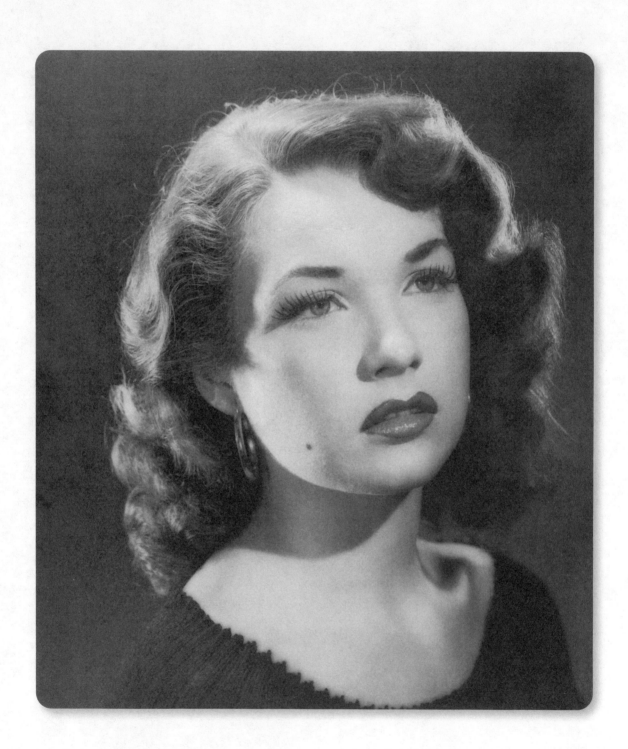

I laugh when I look at this picture today because it reminds me of the movie stars I looked up to. My favorites were Rita Hayworth and Maria Montez—probably because they both danced. I had a professional photographer take this picture because I wanted to see what I could look like, what I could be. (The eyelashes are real, by the way, and my hair is a beautiful, natural red.) But to be honest, I didn't focus on how I looked. And since it didn't mean much to me, I never learned beauty's secrets.

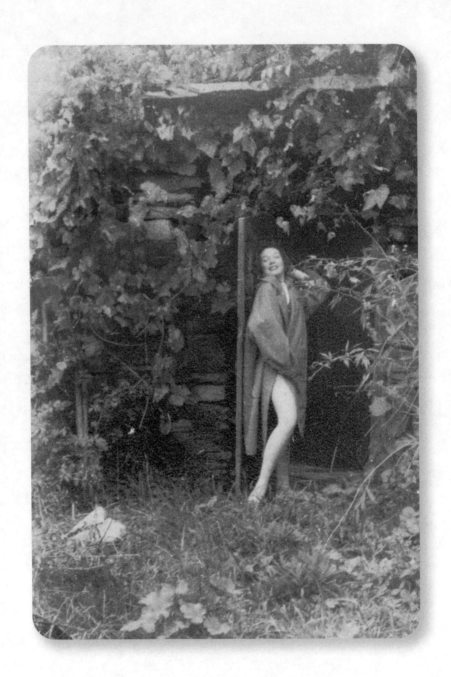

At age sixteen, I decided I was going to move to New York for the summer between junior and senior year of high school to see if I could get a job dancing or performing, even though I'd never had an acting lesson or acting teacher. (It wasn't going to be the ballet, though. I was five-foot-seven but six feet on pointe, so they couldn't easily partner me with male dancers.) My parents had been letting me take the bus by myself for years to Washington, D.C., since before I was a teenager, so I guess it's not too much of a surprise that I flew to New York alone not long after.

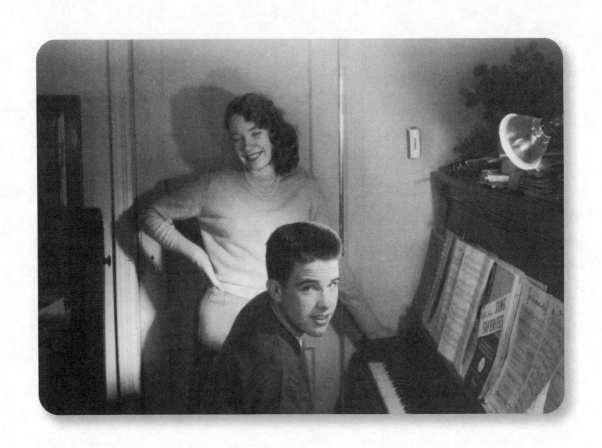

ere, Warren was playing me a goodbye tune before I left. (I think he wished he could come, too.) I'm not sure my parents wanted me to run off and be a performer, but they knew I needed some freedom. And I think they wanted me to go ahead and do what I wanted to do so they wouldn't have to worry about me—they had busy lives of their own.

Part 2

# New York, New York

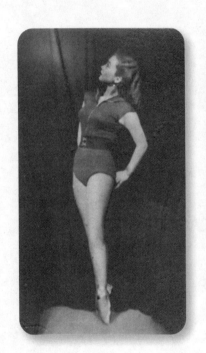 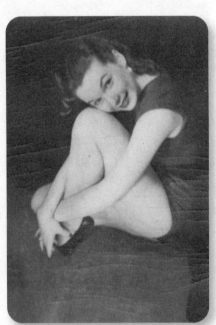 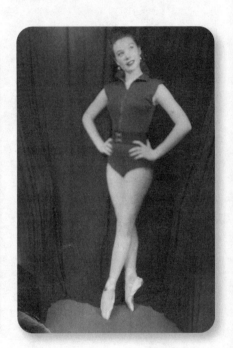

In New York, I lived at the Three Arts Club, a residence on West Eighty-fifth Street for girls pursuing a career in theater, music, or art. There were ten beds and ten bodies to a room. If we weren't working, we were going to dancing class all day, every day, or *talking* about dancing class. I walked to my lessons on Sixty-eighth and Madison because I couldn't afford a cab, and the bus didn't go downtown, only uptown. I stopped at the Automat for food because that's all I could afford. To me, New York was not about excitement or fun—it was about working hard. A lot of boys visited the residence, but I was too busy; I never went on a date. My parents didn't visit, but we kept in touch on the phone. And I never talked to Warren; he was busy, off playing football. When I went out auditioning, people thought I was older, and I was offered a job in the chorus of the "subway circuit" of *Oklahoma!* and got to do the show in all the boroughs of New York.

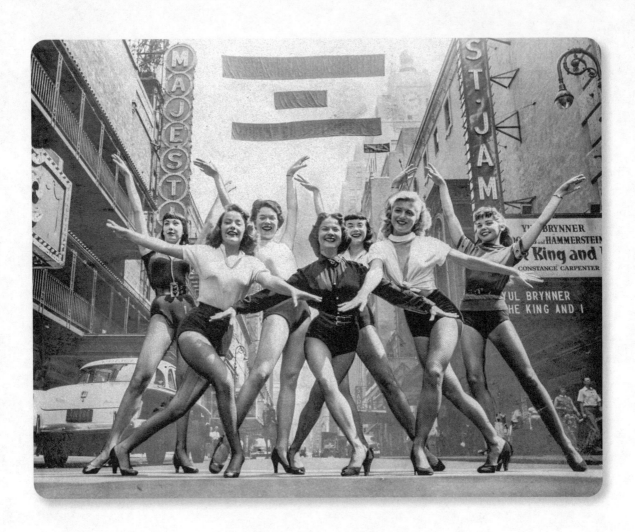

I wonder what they're doing today.

At seventeen, I returned to Virginia to graduate from high school. I don't remember the day, but I remember knowing that it was very important to my father that I finish school. And I had a boyfriend then in Virginia, but I told him to be careful not to get too involved with me because I was going to do things. Almost immediately after high school, I went back to New York and got into a musical called *Me and Juliet*—probably because of my legs. They might have been too long and made ballet a difficult proposition, but they were exactly what they wanted for Broadway. I had exactly one line: "Seems like only yesterday that Susie left the show."

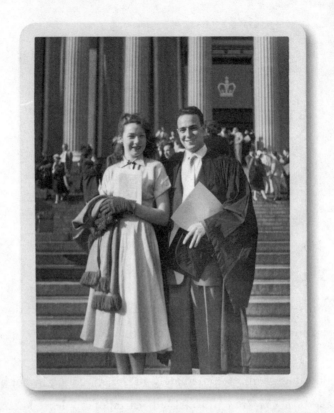
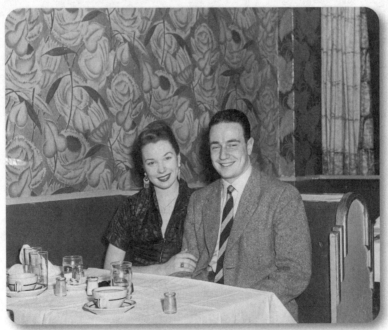

Me and my first love, George Huvos, on his college graduation day. I first met him when I was seventeen and sitting on a blanket with friends in a park near Columbia University, where he was a student. Sometimes, I've wondered if I should've gone to college. I had gotten all A's in high school but turned down the opportunity. I was the only one in my family who didn't go, but I just knew that everything would happen for me. I don't know why, but I did. And luckily, I had George, who was an intellectual and opened my world to thinking. He wanted to get married, and I did seriously consider it. I remember coming back on a long train ride from outside the city, mulling over the idea the whole way. But in the end, my reason for not saying yes was about my career. I was already thinking that way then. I don't regret it.

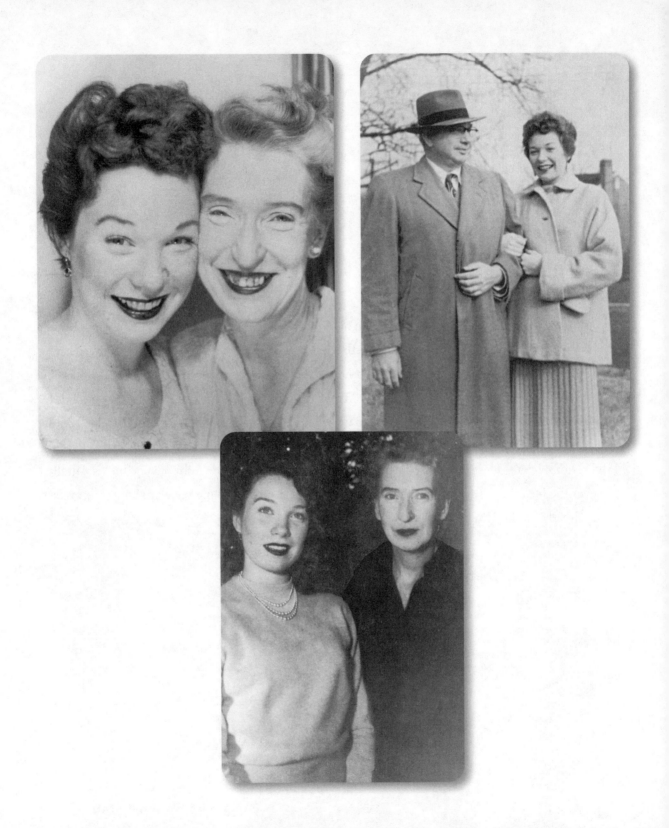

These are photos of me and my mom and dad during early visits home to Virginia from New York. On that first trip back, and even on later ones, it felt like returning to the past, and I wasn't interested in that. I remember that I was contemplating marriage when this picture of Daddy and me was taken, but I didn't mention it to him or Mother. I knew I was young, and I think I knew that George wasn't who I should marry.

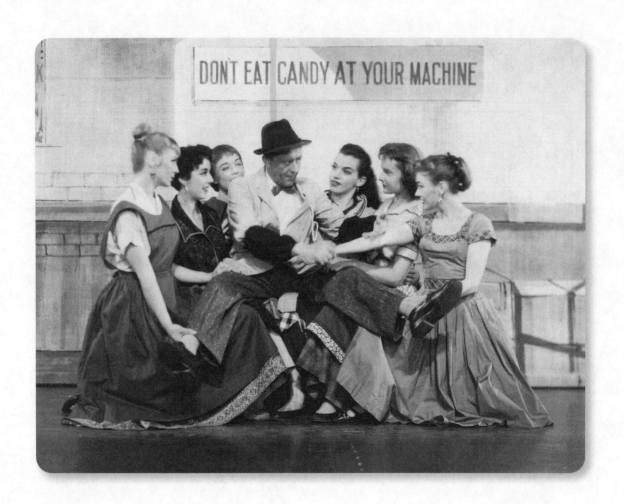

When I was in rehearsals for *Me and Juliet* on Broadway, I used to watch a lithe figure pacing and doing unusual dance movements in the dark in the back of the theater. I was interested in the body movement; it was anxious and yet commanding. There was no communication with anyone but the shadows. The figure was Bob Fosse, the husband of the show's star, Joan McCracken—and nobody knew who he was then. Joan said she thought I had talent, and a few months later, I left *Me and Juliet*, auditioned, and got into a show called *Seven and a Half Cents*—which later became *The Pajama Game*, and Bob Fosse was one of the choreographers, along with Jerry Robbins. During this time, I met and fell in love with a man named Steve Parker. (Around this time I also changed my name from Shirley Beaty, which wasn't easy for people to know how to pronounce. I used my mother's maiden name, MacLean, but tweaked the spelling so it would be pronounced correctly.)

Carol Haney, funny, electric, and an extraordinary dancer, became the star of *Pajama Game*, even though she was in a supporting role. George Abbott, the director, designated me as Carol's understudy, but I never had a rehearsal. I learned the movement by watching from the wings while Steve worked with me at home on remembering the lines. One matinee, unbeknownst to me, Carol had twisted her ankle and couldn't go on. I remember every detail of that day when I got home from a trip to Jones Beach. When I arrived at the stage door for my part in the chorus for the night show, Bob Fosse, Michael Bennett, George Abbott, and Hal Prince were in a line waiting for me. I was five minutes late, and in unison I heard them say: "You're on for Haney tonight." All I could think was *I'm gonna drop the hat in "Steam Heat,"* which is one of the most difficult pieces of choreography there is. I had been a dancer most of my life, but now I had to become a moving physicist.

When the stage manager announced to the audience that Carol Haney would be out and someone else would replace her, the audience booed and some people even threw things on the stage. The cast had all signed a good-luck paper that I still have. Then the curtain went up and there I was. The cast crowded into both stage left and right, on one another's shoulders. There was a smattering of applause, and I proceeded with what I had learned from the wings. I had to wear my own gym shoes because Carol's feet were so much smaller than mine. The second act began with "Steam Heat." A huge spotlight slammed into my face, and yes, I dropped the hat. I picked it up and said,

"Shit," but some people applauded. And when the number ended, some people in the audience stood up. I began to enjoy myself, and when the show was over, my fellow "Steam Heat" dancers, Buzz Miller and Peter Gennaro, rushed to me during the curtain call and hugged me. So did the audience—by standing up. I took a very deep breath, and from that moment I realized that my life was completely changed. I was on for Carol for about two and a half weeks. Steve was my rock-solid security, and I rehearsed every day—sometimes wondering if I was overdoing it. The word got out that I was good . . . Alfred Hitchcock came and asked me to do his new picture *The Trouble with Harry*, and Hal Wallis came and signed me to a five-year contract in Hollywood. For the time being, I went back to the chorus, but at eighteen my future had been secured. Hitchcock wanted me in a few weeks to start shooting *Harry* in Vermont.

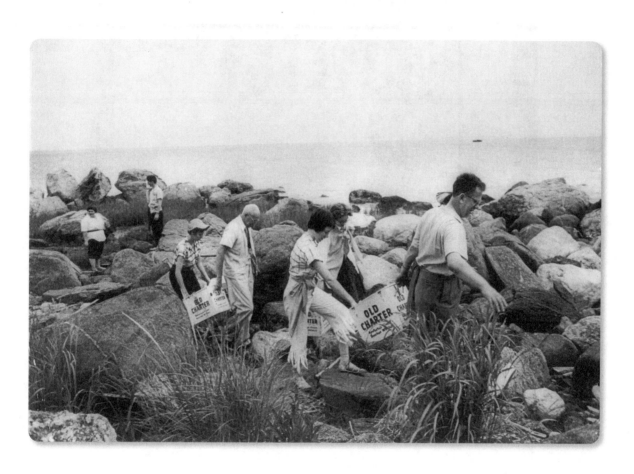

I went for a walk with George Abbott the day I made my surprise debut and had to rush back to New York.

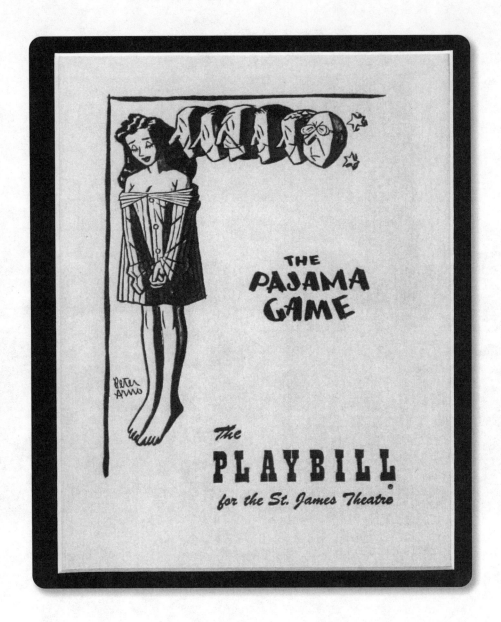

The *Playbill* commemorating the first night of my career as a Broadway leading lady. I'll never forget that performance.

*Pajama Game* was also a notable moment in my career because it was when I established my "signature look." Carol Haney had short hair, and with all of the action and props that went with her character, it was a necessary style. When I was in the chorus, I used to pin my hair up, but it would come undone in front of the audience, so we needed a more permanent solution when I took on her part. One day, very unceremoniously, the stage manager sat me down in the basement and cut off all of my beautiful, long red hair. I didn't mind, though; I actually liked it. But that was the beginning of being in a world in which people just thought they had a right to your being. And it prepared me for Hollywood and being cultivated for the screen. I never objected to it, though; I was very pliable. Isn't that interesting?

I guess Steve liked my new look, too.

When I met Steve Parker, the attraction was immediate, on both our parts. I will never forget the way he looked into my eyes—through to my brain. He was extremely intelligent and funny and eleven years older, but he made me feel that I knew what I was doing. We walked the streets of New York. We met the next day and talked for hours. He told me about his travels and his unsuccessful attempt at trying to be an actor. By the end of that day, I knew I would marry him. But what I didn't know was what he did for a living. He was busy, though, and so was I, so I didn't really question it. Some weeks later he moved in with me. Steve was a good cook and made all the meals and taught me how to drive. I told George Huvos about Steve, and he said he was heartbroken but understood. I told my parents—my father did a background check on him and found nothing. They were upset at the difference in our ages. One evening Steve took me to his favorite restaurant— he grew silent—and I knew he was grappling with his next words. "You must never tell anyone what I'm going to say, but I think you should know." And then he spoke: "I am undercover with military intelligence, and work in Japan regularly, as well as other places throughout the world. You must promise me your silence." I did. He told me more about his background and that of his father, which I won't disclose. A few weeks later we married. When I told my parents that I had wed him, they were furious. In fact, a long period of time ensued without our talking. I carried on my life the best I could without them or Warren.

Part 3

# Hollywood, Part 1

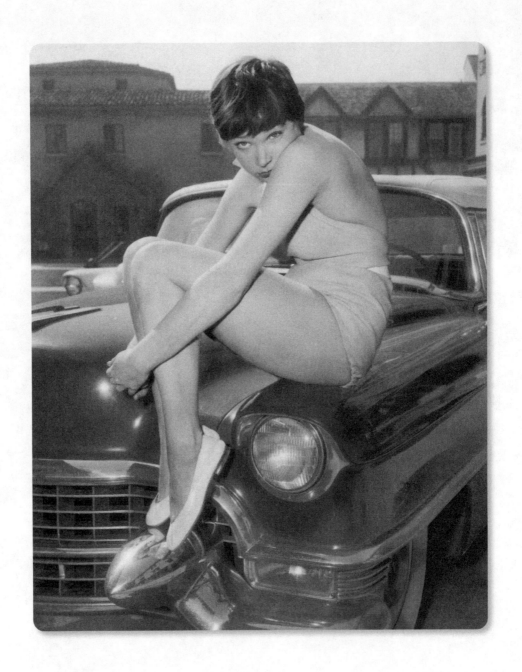

On the Paramount lot, there were always photographers all over the place, and if I had a notion for a picture, we could easily take one. This almost looks like a cheesecake shot, but I think I'm actually just being me here. All curled up, trying not to be noticed, watching other people, watching what they're doing . . .

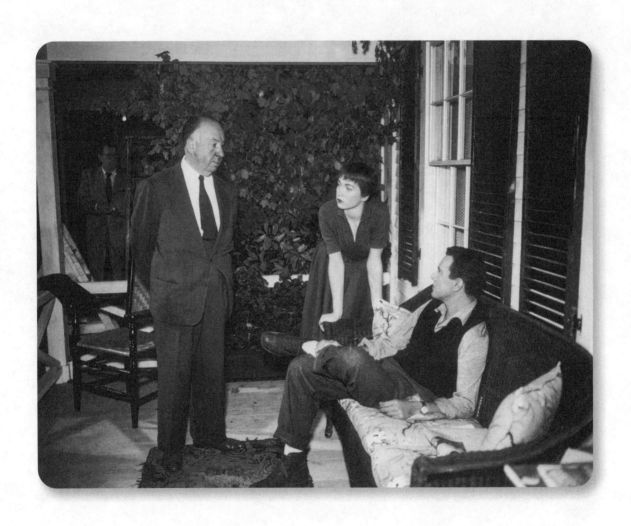

I turned in my notice at *The Pajama Game* to work on *The Trouble with Harry*. I married Steve because I needed the security, despite knowing that Hitchcock hated husbands and lovers. Years later, I learned that being blond and thin would be a problem in terms of Hitchcockian behavior. Fortunately, I had dark red hair and was a size 12. Steve politely respected Hitchcock's aversion and stayed away during the day when we shot. Hitch invited me to every lunch. I gained twenty-five pounds, but that was OK for the part. I found him funny, sarcastic, and able to direct by saying nothing. I loved the shoot, the cast, and Steve—who I would go back to the hotel to see every night. My costar, John Forsythe, helped me become a professional; I learned to always be there when they called, and I memorized every line in the script. He once even picked me up when I fell down. Acting in front of the camera seemed natural to me. I didn't even know it was there. I just understood to go where the light shined. And as for Broadway, I hadn't had enough of it to miss it.

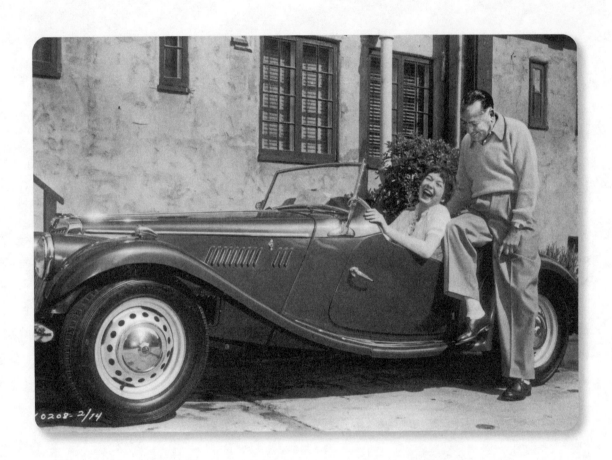

I drove in a rented car (by myself!) to meet Hal Wallis for the first time at Paramount. I rode through the front gate and watched him walk toward me in front of a sound stage. I rolled down my window to greet him; Wallis leaned in to kiss me and stuck his tongue down my throat. I pulled back and spit in his face. He simply walked away, and I probably should have been afraid he might retaliate, but it didn't occur to me; I was just too young and naïve to be afraid. Believe it or not, that was the first and last time I ever had anybody come on to me or be that forward in Hollywood. Wallis never apologized, but a few weeks later he gave me this MG from London, and it was the beginning of our five-year, very professional relationship. I wonder if I'm actually laughing at him in this picture.

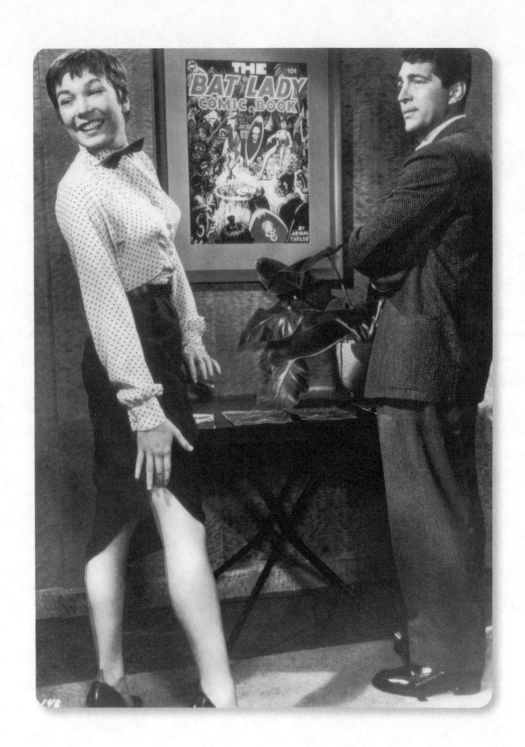

I begrudgingly obeyed Hal Wallis and made my second movie, *Artists and Models*; I played the Bat Lady. My costars were Dean Martin and Jerry Lewis, back when they were still a team. I didn't care much for Jerry. He was overpowering and controlling, and I didn't think he was very funny. Dean, on the other hand, was the funniest person I ever met. He was spontaneous and totally aware of everything around him, and I saw that Jerry knew it. My dressing room was in between Shirley Booth's and Lizabeth Scott's. Lizabeth was having an affair with Hal Wallis, and the very nice Shirley Booth had just won an Oscar.

Making *Artists and Models* in Hollywood at a studio was an entirely different experience from making *The Trouble with Harry* on location. It also fostered a type of loneliness and distance from the people I worked with. After every shot, I returned to my dressing room; so did Dean and Jerry. The set, pictured here, was a home for "interiors" and the brilliant work of the crew. There was a musical scene on a flight of stairs, and I was dressed in a yellow sunsuit. I could see that Jerry was jealous of the attention my legs got and the fact that I could sing a little. I remember a mix-up in the choreography, and Jerry just walked off the set. I stopped singing and dancing and didn't know what to do. He was over in a corner pouting. Apparently, the crew was used to witnessing this type of behavior, but I was very confused. Since time was money, after about fifteen minutes, Wallis, the producer, appeared. I sat on the stairs while Wallis forced Jerry to return to continue filming. Dean sat smoking, also used to Jerry's behavior. I still don't really know the reason for Jerry's tantrum.

At the end of the shoot that day, Jerry took me into his dressing room and flaunted all kinds of technological equipment in my face. He said he was going to direct the next motion picture he was in. I didn't tell him that I knew this was his and Dean's second-to-last picture together because Dean couldn't bear it anymore. (My agent was their agent.) I remember my agent telling me two years later that Dean shook hands with Jerry, said goodbye, walked out, and slammed the door. It was years before they met again.

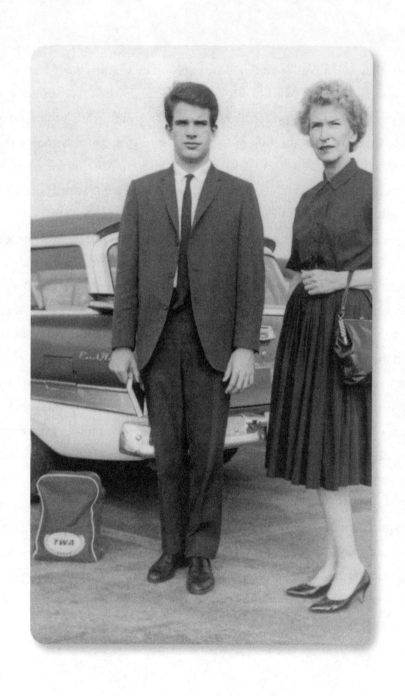

Warren played serious football, and Mother worried (as did I) about physical injury. Washington Lee High School was famous for its football team. Warren was popular and made good grades. We didn't stay much in touch with each other. I was busy in Hollywood and he was busy in high school. I don't know what got him interested in acting, except he did it in real life. After he graduated, he went to Northwestern University. I don't know why he left college and went to New York and into a Broadway play. He seemed so private. I didn't question him. I stayed close with Mother and Daddy but didn't know what Warren was doing.

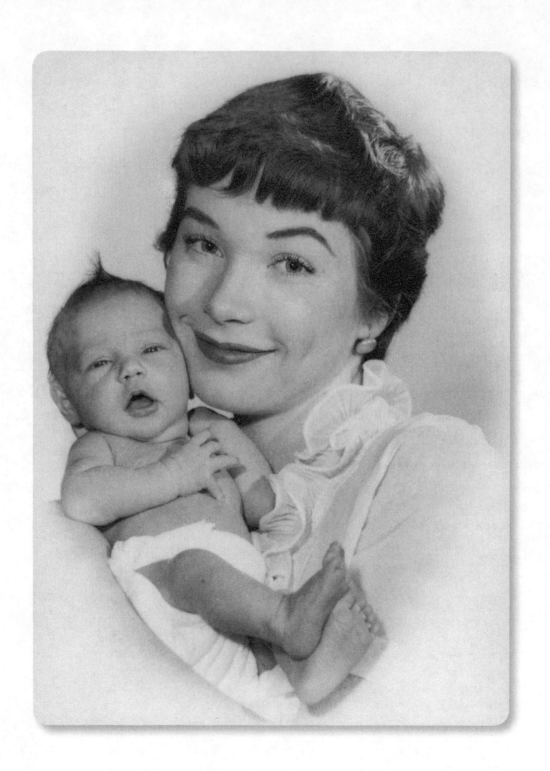

During one of Steve's and my honeymoon trips to Japan, I became pregnant. I didn't want to eat—I was slightly nauseous—and didn't find out what was happening until I returned to Malibu. Steve was a bit shocked but happy. I was only twenty-one and still a baby myself. A few months later, Steve needed to return to Japan. I went through most of my pregnancy alone. My team in Hollywood were with me, even though they thought I was crazy to have a child at such a young age when my career was booming. In fact, I returned to Japan while four months pregnant to shoot on location for *Around the World in 80 Days*. No one knew about my condition. Steve took care of me like a doctor would, and I tried to cover up my stomach with a sari, which was my costume as an Indian princess. After the location work, Steve stayed in Japan and I returned to Malibu. Steve came home for Sachi's birth, and we moved into a house that was a little bit larger in Malibu proper. I was walking and driving the car the day after my daughter was born, and loved taking her in a bundle everywhere I went. She rarely cried, and instead laughed all the time. I loved being a mother. She was like a baby sister to me, whom I nursed for about six months. I sent pictures to Mother and Daddy, and Warren came and held her. He was now an uncle and beginning his career around Hollywood as a ladies' man. Because I now had money, Steve and I moved into the Malibu Colony with a spare room for Sachi's new nurse-caretaker. I walked on the beach with Sachi in my arms and she often pee-peed in the ocean. Our first year together felt like we were beach camping. I never wondered if the lifestyle was good for her, and she was never sick. When she was two and a half, I went back to work on *The Sheepman* with Glenn Ford. The nurse brought her to the set and the crew adored her. I've often wondered if that's why she ventured into show business when she was very young. She came to all my sets, and the wardrobe girls would dress her up.

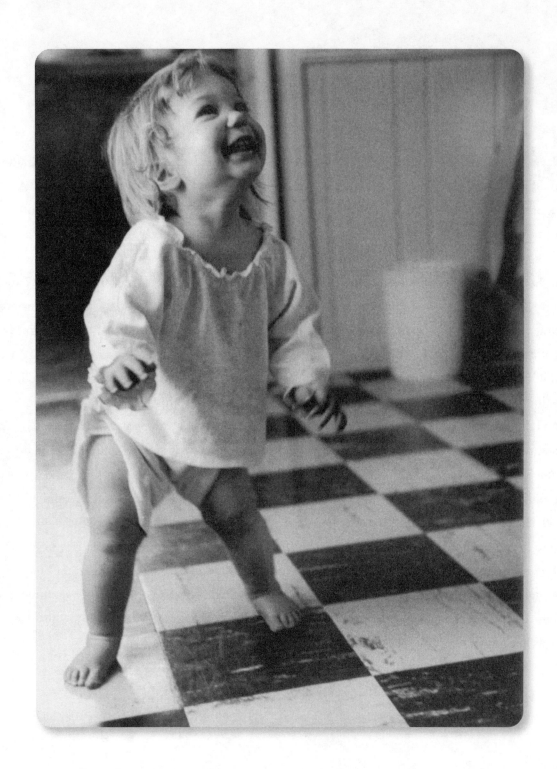

Sachi at this age was just adorable, easy. I was so lucky to have a camera to record her first step in the world—so was she.

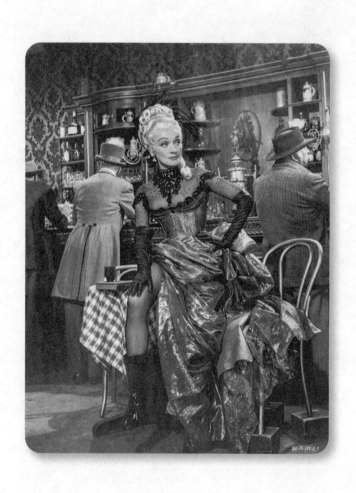

The science of the camera is extremely complicated and sophisticated. I remember Marlene Dietrich taking me around the set of *Around the World in 80 Days* and teaching me where the camera should go in relation to the lighting. She was very generous, and the crew completely understood. They stood up and listened to her telling me, because she knew as much as they did. She had been a movie star for decades and was known to be an expert in lighting and camera angles. She had a certain awareness of these things while on set, which you can even tell from the photograph here. I think she helped me because I was young and one of her favorites on set and didn't know what I was doing. But I also think she saw how people were treating me as somebody important and wanted to come across as being my teacher. But she took the time and was very nice to me. I never did learn the science of camera close-ups, though. I was too busy saying my lines as they had been written and expressing the emotion intended within them.

During *80 Days*, Marlene seemed to be having an affair with producer Mike Todd. One day, she positioned herself up against a tree and proceeded to enact fifteen different movements while Mike shot stills from the wings. But he directed some of his attention my way as well and told me, "The highest degree of intelligence in Indian princesses could be evaluated in their blue eyes, red hair, and freckles." I can't believe how you can talk people into things; I mean . . .

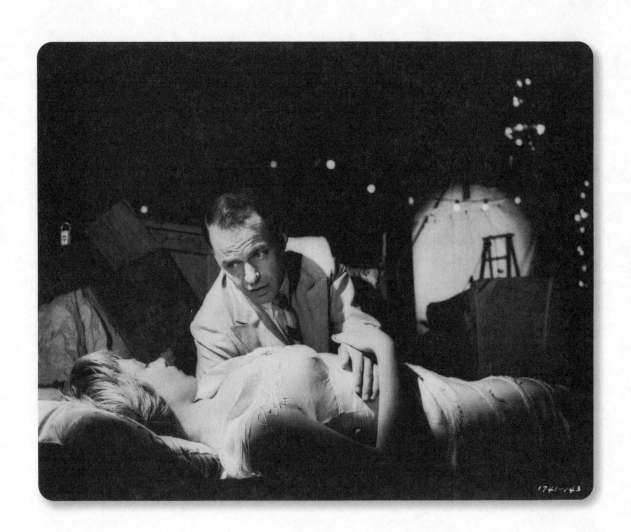

After *80 Days*, I did *Some Came Running*. I hadn't read the James Jones novel it was based on, but Frank Sinatra sent me the script. Originally, his character was supposed to die in the end. Frank told Fox, "Let the kid die, not me. She'll get a nomination." This was my first experience working with both Dean and Frank, and this was one of the many scenes that Frank and I had together. It was a dream for me. I entered their lives and became the mascot of "the clan," which is what we actually called the Rat Pack. But it wasn't a dream for Vincente Minnelli, the director of the movie. Frank was very loose with his performance; he only wanted to remember his lines and wasn't that involved with the acting. Neither he nor Dean appreciated Minnelli, because Vincente didn't say anything except direct the curtains. At some point while we were shooting in Indiana, Frank and Dean got upset about something—I'm not sure what—but they went to the airport, got on a plane, and flew back to L.A. Sol Siegel, the producer and head of MGM, had to go and get them. I was watching all that and just thinking, *Oh my God!* But yes, I did get nominated for an Oscar, and my career really took off.

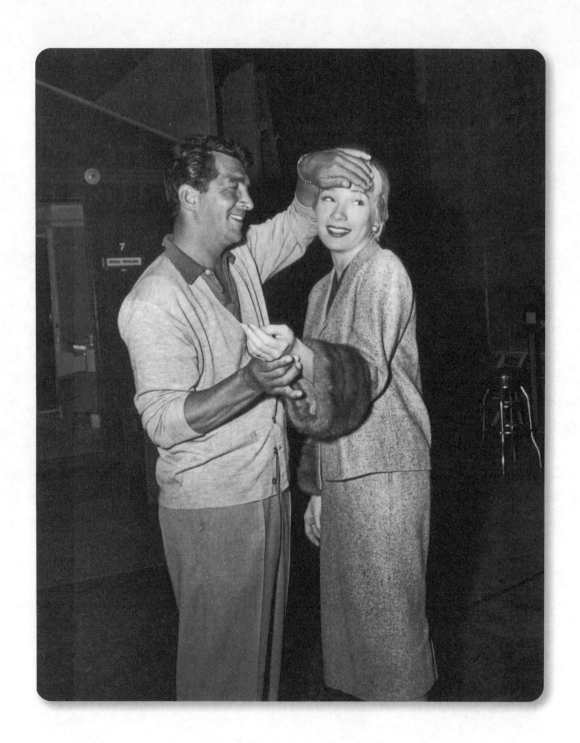

Here's Dean Martin taking my temperature on the set of *Career*, where I dyed my hair extra blond. It was a drama, but I laughed all the way through it because of him. And at dinners, I barely ate because I was too busy cracking up. But people probably didn't think of him as funny because he had to be *unfunny* with Jerry. He was much more sophisticated than Jerry, so you never got to see the funnier side of him until you knew him. And he was careful when he would display that sense of humor; I think he wanted to be known as a leading man. I developed a crush on Dean, but it never went anywhere because I was friends with his wife, Jeannie. When he and Jerry first broke up, I worried about how Dean would do on his own. For a little bit, his films and career were so-so. Soon, though, he was paired up with Frank Sinatra in front of a live audience. Dean was the funny one and again paired with someone who loved control too much, but Frank couldn't make anyone laugh.

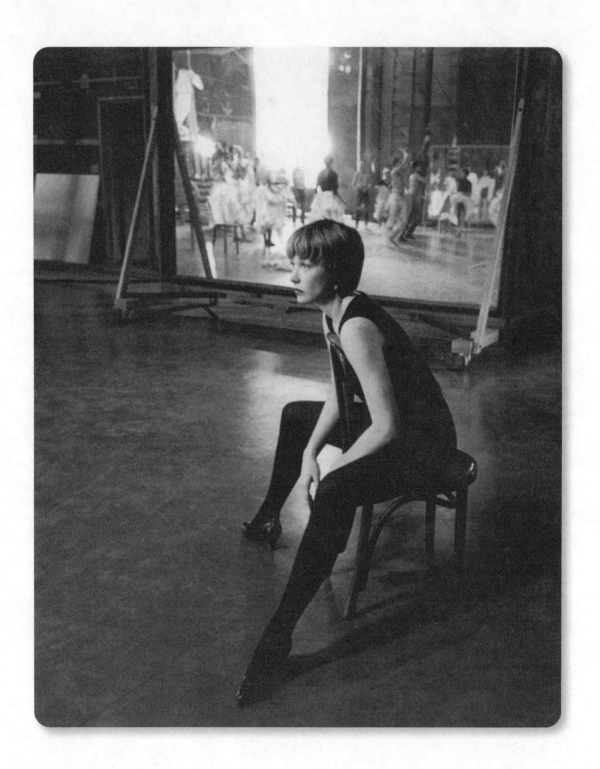

Taking a break on the set of *Can-Can*. All of my dancing classes had led to this. I was the star of the movie, along with Frank. It was my first movie musical role, and as a dancer, I didn't feel up to it. It was devastatingly different from dancing in a Broadway show. I can remember doing the can-can maybe eighteen times, and that's hard. And at this point, I was the lead and could have said, "Let's not do this again until tomorrow," but I never pulled rank. I did whatever they wanted and had a sense of loyalty to those in the chorus. I had respect for everybody who was working hard, too.

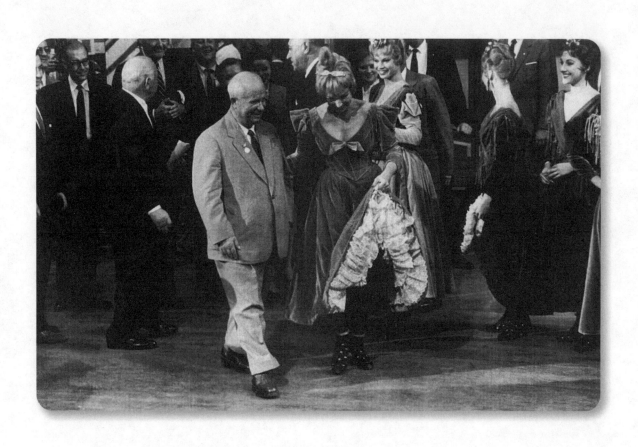

Nikita Khrushchev was open and friendly when he visited the *Can-Can* set. He didn't know who Frank Sinatra was and remained somber when watching us dance. He told me we shouldn't have worn pantaloons for the Can-Can. He said he was being "historically accurate." I think maybe he was right . . . if we had been in Paris. He also is known for saying after watching us perform, "The face of humanity is prettier than its backside."

Later, when he returned to New York to famously bang his fist on the UN table, we both found ourselves having dinner (separately) at Sardi's. A note came to my table. When I read it, I laughed out loud. It said, "I saw *The Apartment*. You've improved." When my eyes located him at his table, he gave me two thumbs up. No getting up and crossing the room for a handshake. It would attract too much attention. I liked him.

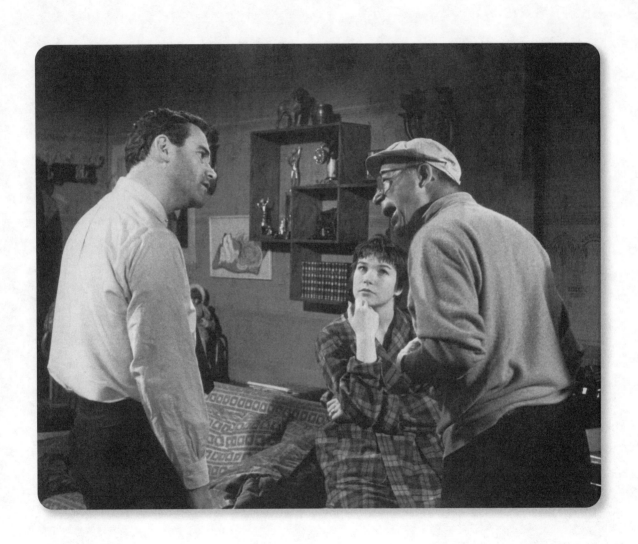

Billy Wilder directing the darling Jack Lemmon and me in *The Apartment*. Billy could be problematic with women. I didn't have any issues with him, but I could feel it, and that had been Marilyn Monroe's problem. But he was a great director and he specifically wanted me for the part. When we began the movie, we had only twenty-eight pages of script and didn't even know how it was going to end or whether Jack and I would end up together. Billy and Izzy Diamond finished writing it only after watching the two of us interact. I was nominated for Best Actress for the role, but on Oscar night, I was in Japan filming *My Geisha*. I think I went there because I knew Elizabeth Taylor was going to win for *Butterfield 8*. I found out on the radio that I'd lost. Some people thought she got the award in a sympathy vote after almost dying of pneumonia that year, and while I was disappointed, she was a brilliant actress and one of my best friends and a real sweetheart. (When Steve was away and I was alone, I would go over to see her on Beverly Estates Drive.) Whatever happened, *The Apartment* is still one of my favorite films.

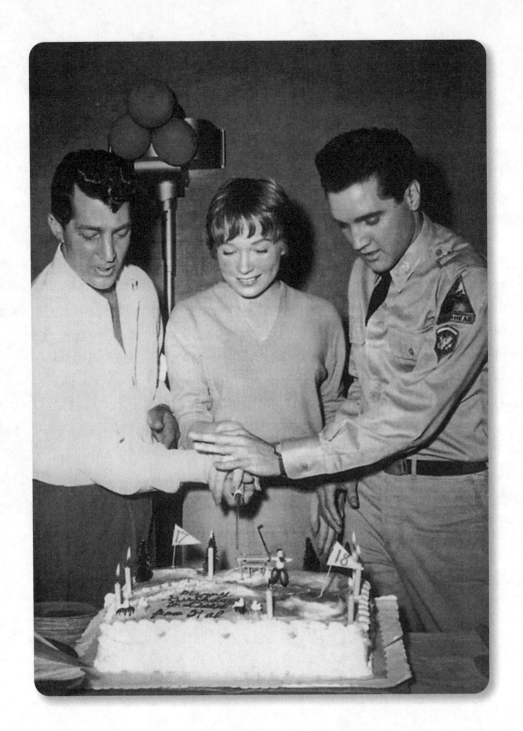

Celebrating Dean's birthday on the set of *G.I. Blues*.

At the time of this photograph, Dean's and Elvis's dressing rooms were across from mine. Elvis was really nice, but his politeness guarded him against people getting to know him very well. He would come to me, though, for advice on how to behave on set, how to talk with the director. Colonel Parker was usually his voice, but he didn't know that world, either. Dean was actually very respectful of the singer-turned-actor.

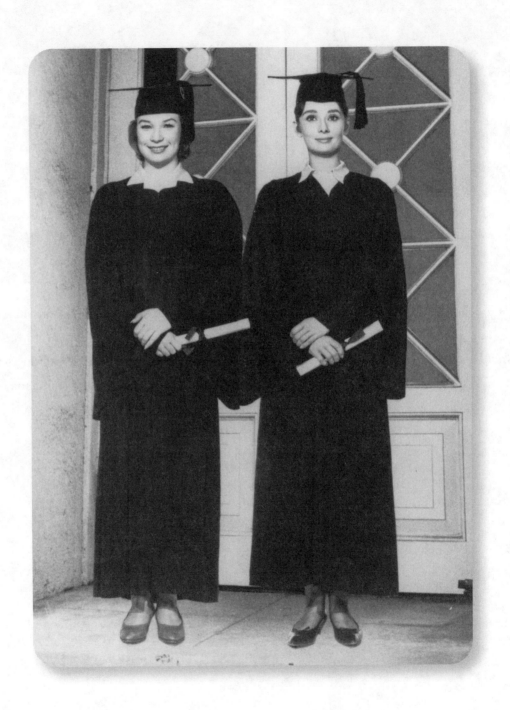

On set with Audrey Hepburn in *The Children's Hour*, one of the first major Hollywood movies to directly address the then-controversial subject of homosexuality. I grew up in the ballet, where a lot of people were gay, so that was never something that bothered me. Audrey also grew up in the ballet, so it felt like we were already old friends, and I adored working with her. She taught me a little about dressing; I taught her a little bit about cussing. I had a crush on the director, William Wyler—on his soul, specifically—and after filming, Audrey and I were friends for years.

Also in 1961, they offered me the role of Holly Golightly in *Breakfast at Tiffany's*, but I turned it down because I didn't want to have to worry about my weight to be able to wear all those outfits and do all those fittings. I legendarily hated fittings. I also didn't think it was a very good script. The producers were very disappointed. At one point, though, I did think, *I should have done that and stayed thin*, but I don't really regret it.

Sachi and me in Hong Kong.

Sachi and I took this photograph when she came with me to Paris to shoot *Irma La Douce*.
She ate everything in sight.

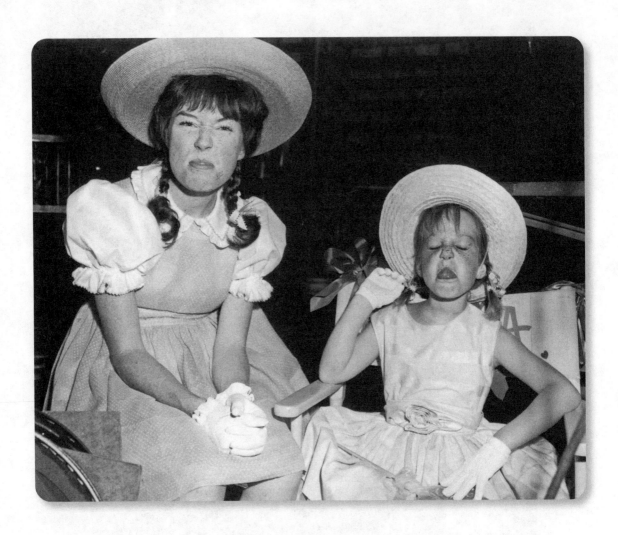

On set, being photographed during *Irma*.

It was difficult to balance being a mother and a new star. I tried to keep Sachi out of the public eye, and my favorite memories are those of Sachi and me being together.

Steve and me traveling.

I'm not sure I would say that Steve and I had a happy marriage, but it was a satisfied one. He was gone too much for it to be that happy. He had a mistress in Japan while I had whomever I was with. The first time we really talked about that situation was during my relationship with Robert Mitchum. Steve wanted to know how deeply involved I was, and I wasn't deeply involved enough to get a divorce. And besides, there was too much that depended on our staying married. But Mitchum was a very intelligent, very interesting guy, and he was married, too.

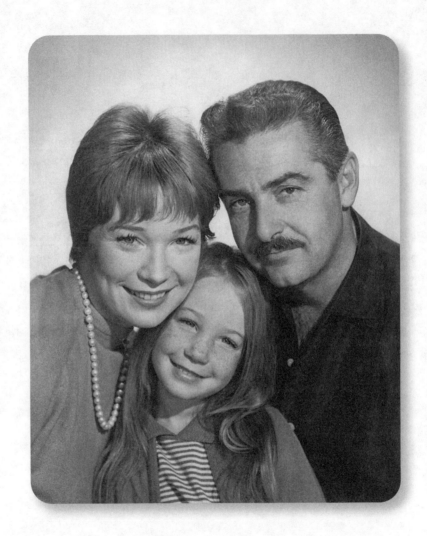

With our beloved daughter.

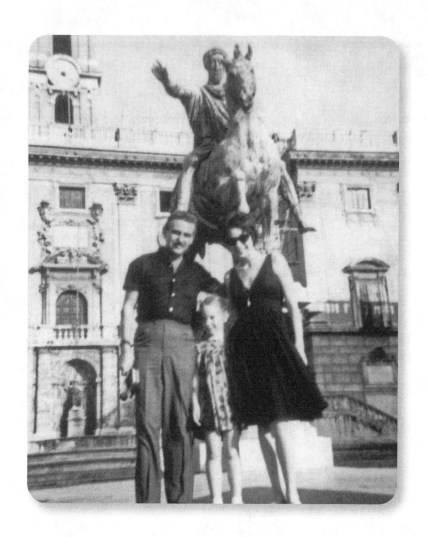

The family in Rome.

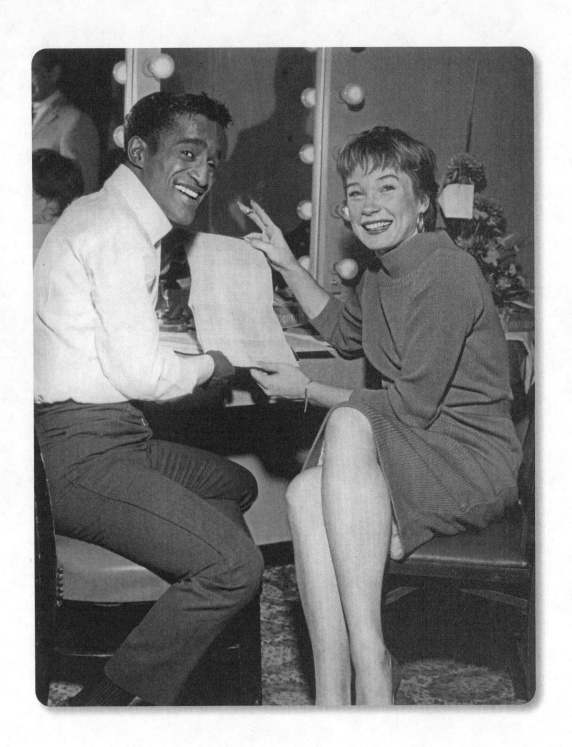

I very much respected Sammy Davis Jr.'s talent, and so did Dean and Frank. When he got on the stage, you got off. He was the most talented of all of us. Sammy could do anything. He could dance, he could sing, he could do comedy, he could do drama. They couldn't do all that. Here we are backstage at one of my shows. Whenever he played, I visited him as well.

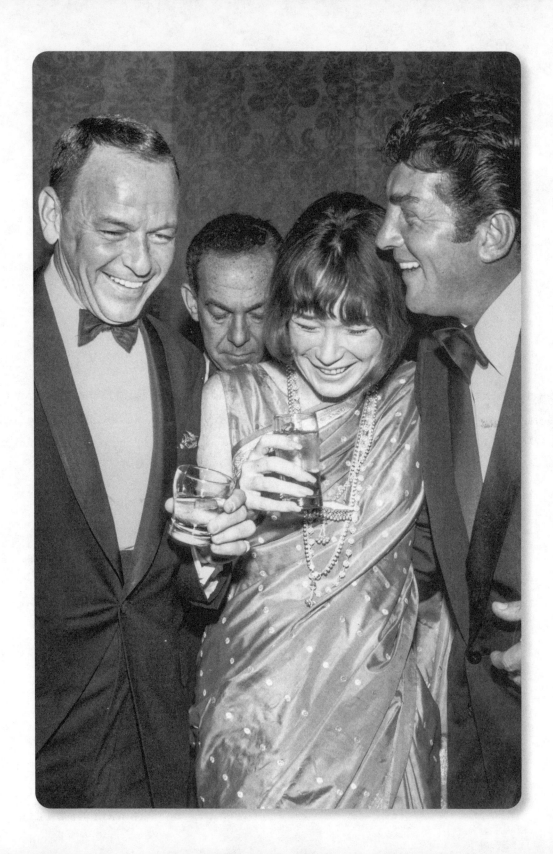

Yes, Frank and Dean knew and sometimes moved with the mob (Sam Giancana taught me how to cheat at cards), but nothing was more powerful to those two than a live audience. The mob went to their knees for them. And I think I was also so interested in Frank and Dean, as well as Sammy, because of how they transformed on the stage with music. I was there for so many performances, worked with them on six films, and became part of their lives. But there was never anything romantic with any of them; I was their mascot—they trusted me, and I trusted them. And they protected me. (Though maybe some of Steve's friends called and said to look after me because he was an important Intelligence guy.) But at the end of the day, I actually preferred buying airplane tickets and visiting a foreign country. In this picture, it's 1965 and I had just returned from India. It was a spiritual experience. I loved being back with the clan, but they didn't know where India was.

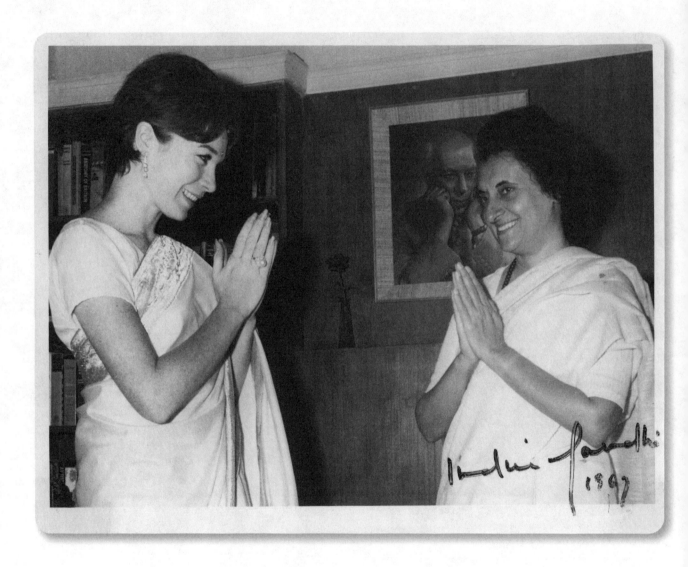

Indira Gandhi
1969

On my first trip to India, I'd planned to go for just a few days but ended up staying a couple of months. (Ironically, they had to put the movie *John Goldfarb, Please Come Home* on hold until I came home.) I flew Pan American airlines to New Delhi, rented a car, and drove south to Madras by myself and then eventually ended up on the west coast. I was growing; I was learning. I was just learning everywhere I went, and that trip to India was a big part of that process for me. And I felt a kinship to the place, the culture. Money wasn't as much of a big deal there, and everyone lives with a spiritual longing or the knowledge of past lives. A couple of years later on another trip there, I met Prime Minister Nehru and his daughter, Indira. They asked to sit next to me on a transatlantic flight, and we talked for hours about everything from the personal to the spiritual to the cultural. He was interested in the Rat Pack and admired Frank and Dean.

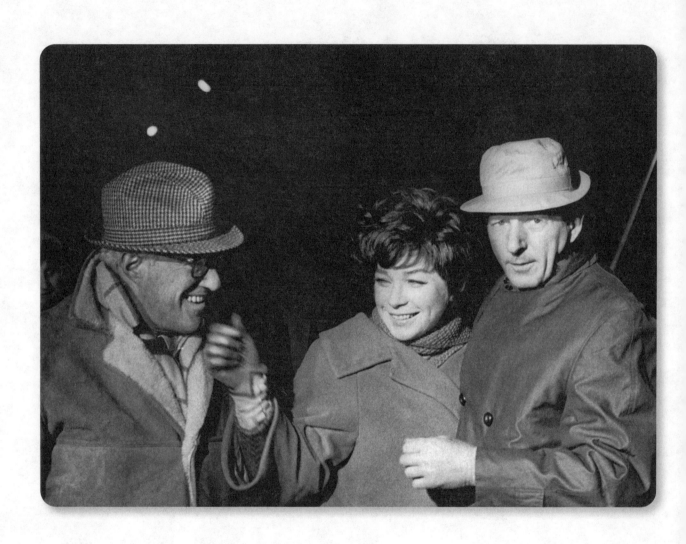

Danny Kaye was a smart, educated, and very complicated guy. He was also a pilot. In this photo, he had flown across the Atlantic in his plane all night to come and be with me in Paris. Vittorio De Sica, whom was I was working with at the time, condoned our relationship. Danny was a prime chef and cooked a meal for the three of us that night in Vittorio's apartment. I found myself making certain Vittorio was sitting in a chair and never tripped when he walked—he was getting older. The film we were shooting was the first time I was nude in front of the crew and camera. I refused to take my clothes off for a film in America, but Vittorio was a father figure to me (even though Danny was old enough to be one, too). Knowing I loved to travel, Danny flew me everywhere. He even flew me to Mexico once just for dinner. The rest of the time he cooked, which was even better.

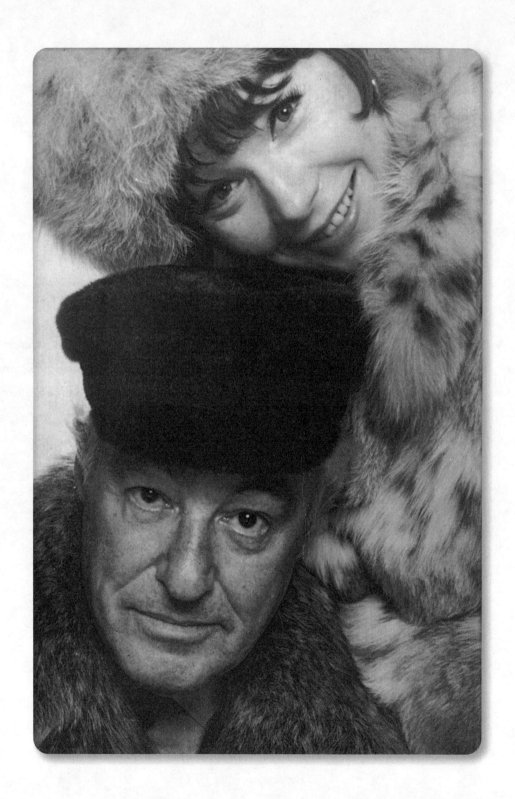

Vittorio De Sica—a brilliant director and a great friend.

Steve became attached to his work in Japan more and more and I never questioned it. Because I was traveling so much and shooting on location, he asked me if Sachi could come and live with him in Japan. So, for both of us, I agreed. My home base then became Tokyo. I quickly grew to admire the culture of respect and politeness there and was fascinated by Japan's ancient history. This is Sachi during her first year of school in Japan. Eventually, Steve and I began to live more separately, but he was still my number one.

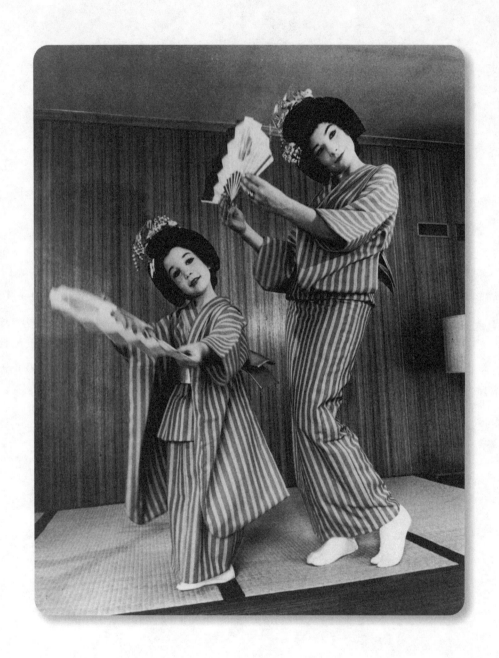

Steve produced the movie *My Geisha,* which was filmed on location in Japan, which allowed me to be there for a few months straight. I was actually allowed to live with real geishas for two weeks and learn their dances and tea ceremony. Here, Sachi and I try a few steps of a traditional geisha performance.

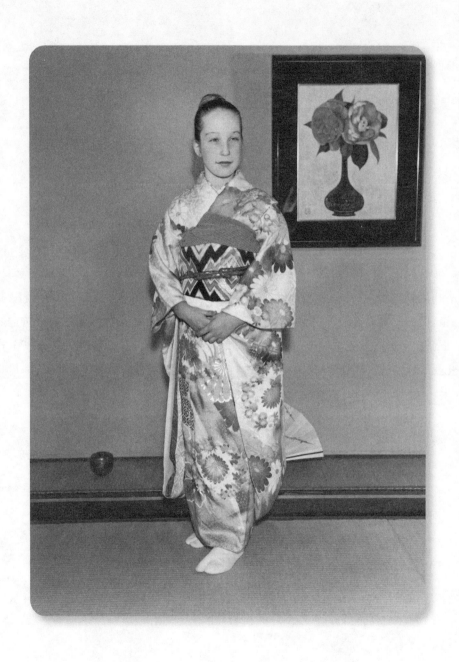

I got Sachi situated in Japan, then left before she could really miss me. I was always working and away a lot of the time and was not there for her; it's something I've always regretted. That's everybody's show-business problem—you have to decide to either be a working star or a parent. But I might have messed her up had I been there.

One silver lining, though, is that Sachi was able to completely immerse herself in Japanese culture and really understand it. She learned to speak and read and write the language fluently.

Part 4

*New Stages*

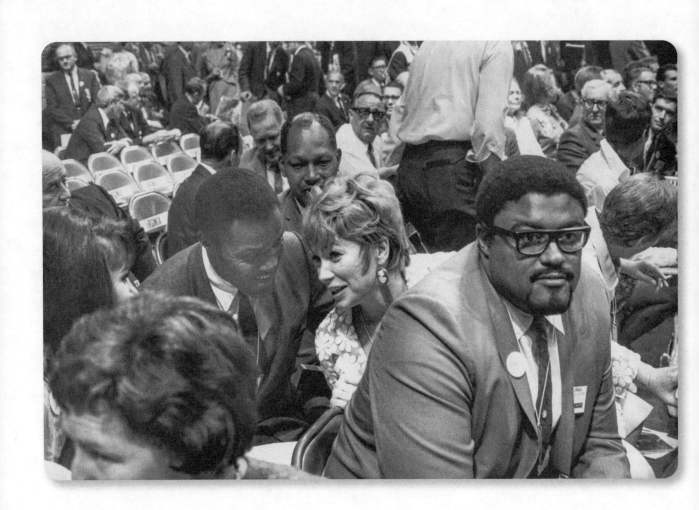

In 1968, I attended the Chicago Democratic Convention as California leader and delegate for George McGovern because I thought he would be a very good liberal president for the country. I attended with Rafer Johnson and Rosey Grier, who acted as my unofficial security amid the violence in the streets that was going on there. My political awareness became more acute that year. America was at war with itself, and we knew that it was a very important convention. But I had always been a person who cared about people, cared about the underdog, and cared about how we could do better in a democracy. I think I've always been very interested in the definition of democracy, because I don't think we know it—and where it can go. I've always wanted to be sure that we understand democracy and that *I* understood it.

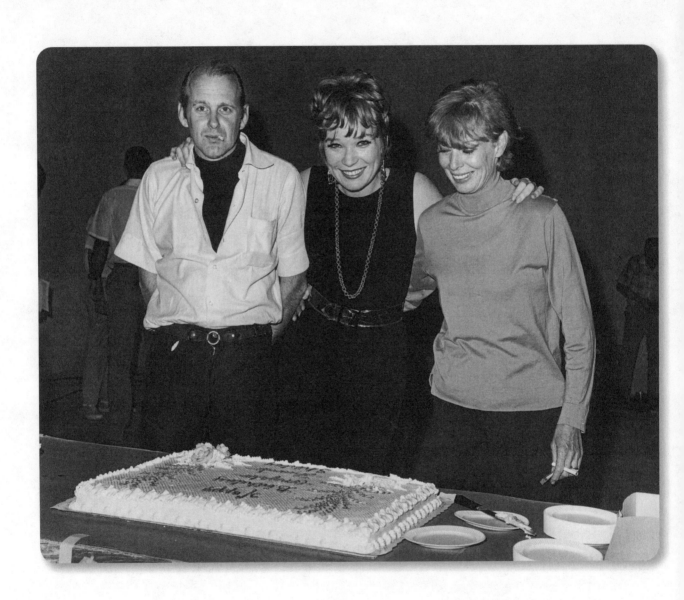

Bob Fosse and Gwen Verdon—my saviors. I returned to Los Angeles to shoot *Sweet Charity*, where we took this photo on set. What I remember most about Fosse is his obsession with detail in movement and his long rehearsal hours. I can remember his "OK, again" at two thirty in the morning in the basement of the theater. No one complained. We complied. When he came to Hollywood to direct the movie, he quietly got rid of the original producer and put his own in position. But for some reason, he didn't say much to me when he did. He was silent and brilliant and needed to be left alone. One time we were having a discussion about a scene and he said, "You brought me here to direct you; let me do it." He was right, but the picture didn't work. It feels like a big, expensive studio movie, and it should have been more intimately conducted. Gwen starred in the show on Broadway and I apologized so many times for getting the role, but she said, "Forget it." I really think she didn't want it. And she was there for me, literally. I turned my ankle out badly and was dancing with that injury and she was helping me between setups. And she was there for him, too. He seemed to be this shy little guy who was also dependent on women.

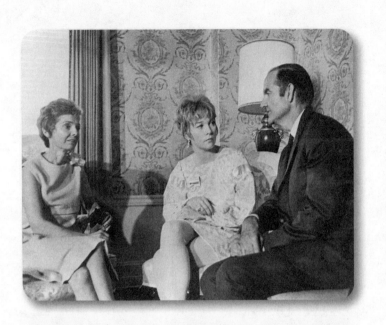
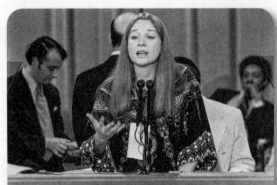

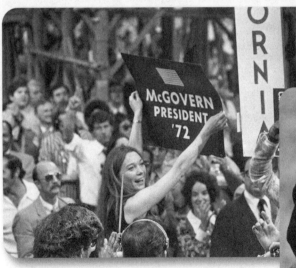
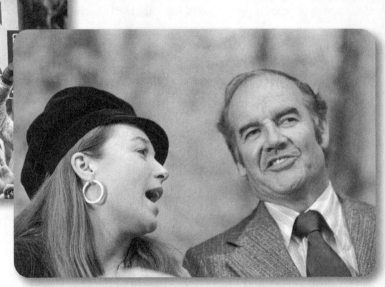

As you can tell by the various states of my hair in these pictures, I was a supporter of George McGovern for president for a long time. He was an intelligent, middle-class lefty candidate. He was also calm and decent and one of the people, but maybe too low-key and maybe a bit boring. He didn't know how to theatricalize himself or his campaign—he didn't have any idea how to do that—but as someone in show business, that actually appealed to me. He was slow in the way he thought and in the way he spoke, but a true liberal. I guess he was too left-wing for too many people, but not for me. Even after disappointing losses, I stuck by him for years.

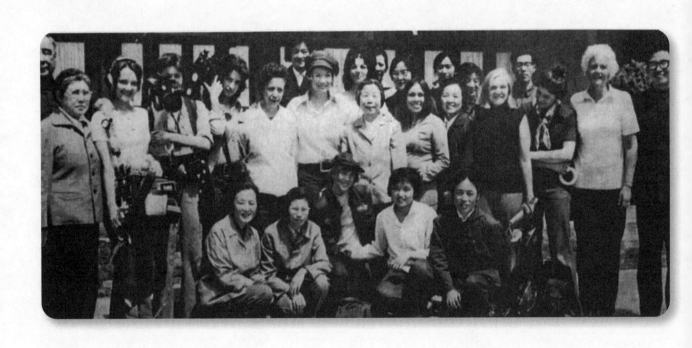

Between 1972 and 1980, I did just three films. I don't think I got any good scripts in that period, but I didn't care and was honestly more interested in seeing the world and understanding what was going on in it. I became more and more involved in politics in general, and in 1973, I went to China as part of an all-female American delegation just to learn and behold everything we could. I was very impressed by China and marveled at seeing women with this seeming equality and lack of pretense; it was as though they were finding a new identity, which was going in the direction of what the men had already established. Along with Claudia Weill, I directed a documentary called *The Other Half of the Sky* that followed four Chinese businesswomen after the economic boom; it was nominated for an Oscar for Best Documentary Feature in 1975.

I went back to the stage with *If They Could See Me Now*, a show of my own, in 1974. A lot of friends and people I'd worked with came out to see me—Liza Minnelli, Goldie Hawn, Lucille Ball, Ginger Rogers, and Gene Kelly. I'd worked with Gene ten years before on the movie *What a Way to Go*. He was a very strict choreographer, but very loose and nice in real life.

I took my 1976 live show, singing and dancing and telling jokes, from the Palace Theatre in New York to the London Palladium, and when we adapted it for TV, we won an Emmy for Outstanding Variety Special.

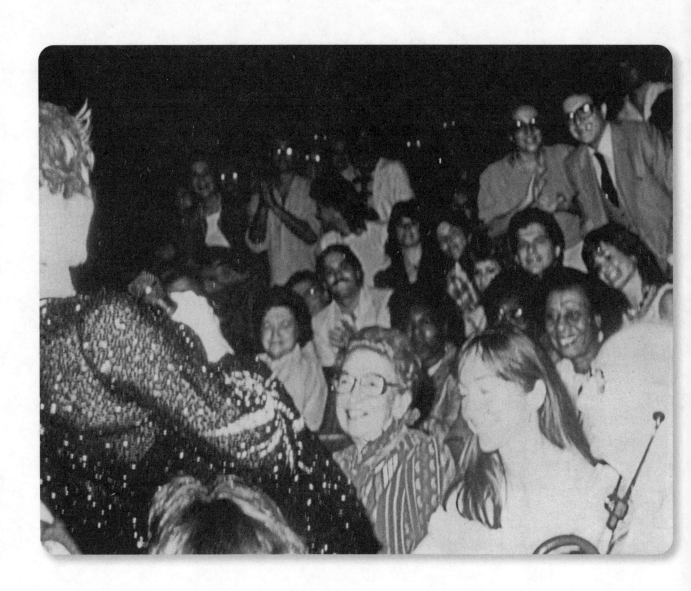

Here I am, a few years later, singing to my mother and Sachi, who are in the audience at the Gershwin Theatre in New York. Mother loved being pointed out and recognized. I dedicated the whole night to her.

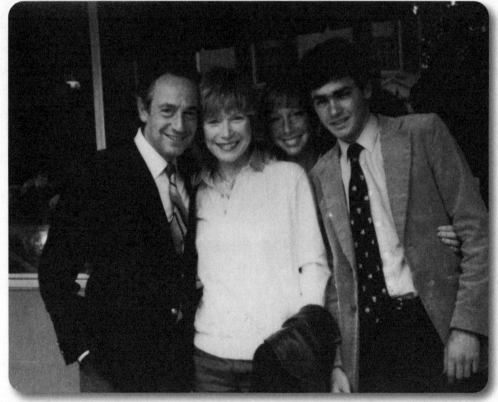

Years later, Sachi and I met up with George Huvos and his son in New York. George and I stayed in touch up until he died; he would call me from Europe on every birthday. I never met his wife, but apparently she went off to another country and disappeared. He thought Steve was a con man, like everybody else, and was probably always in love with me, but I never tried to rekindle anything; the past was the past. I also think he understood we couldn't be together because of my career, which he respected.

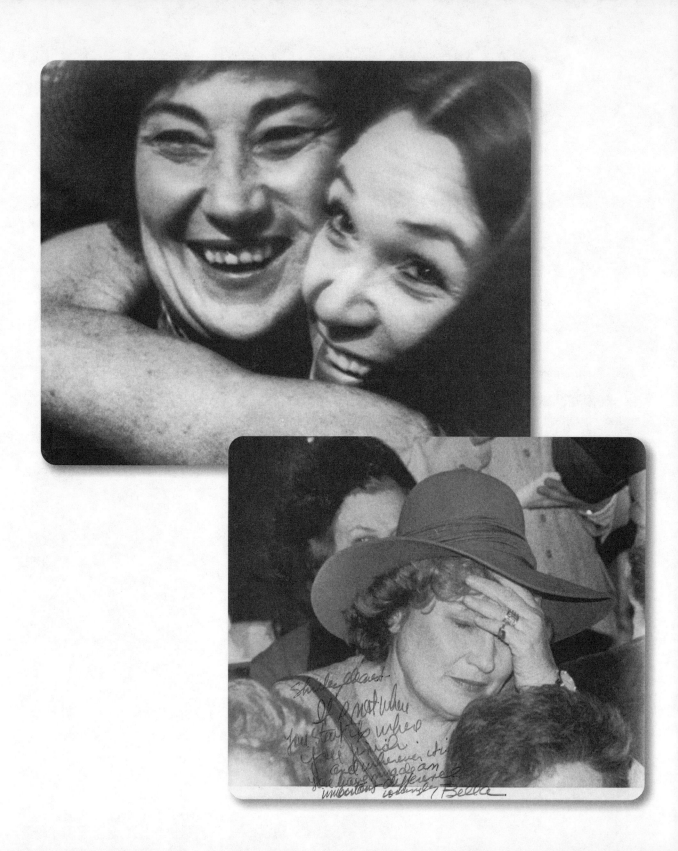

I moved to New York City and met Bella Abzug, who became my best friend for forty years. She was a member of the House of Representatives and the first woman to run for U.S. Senate in New York. She lost by less than 1 percentage point. She should have won. And she should have been president, too, in my opinion. She was an extreme liberal, but she was also very fair-minded, and of course very smart at figuring out other people. I was so taken by her directness, her honesty, and her sense of intelligence. God, she was brilliant. And she wasn't impressed by me at all. But we had fun. She lived in the Village and always came to my apartment on West Seventy-third Street and would take her hat off and her hair would be plastered down and she never noticed. Then we would talk about everything. We were very close; everyone thought we were having an affair. I heard about her death on television, but I wasn't in New York. I was at my ranch. She had been in the hospital, and I didn't even know it. She wouldn't want to do anything to worry anybody.

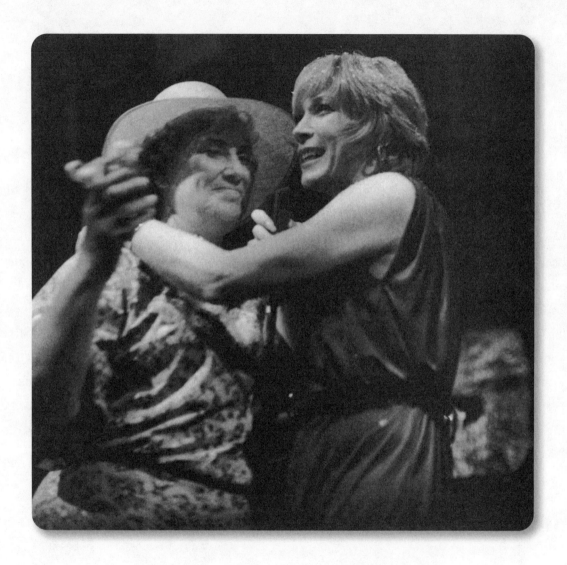

Me and Bella at Studio 54 for her birthday in 1977.

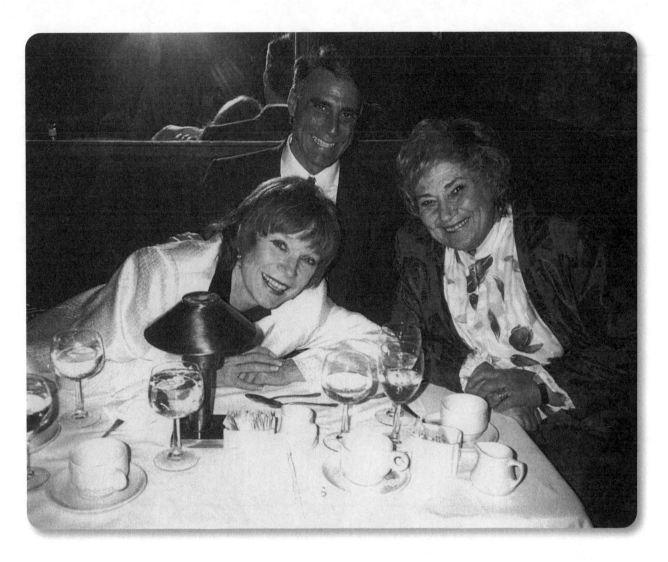

My good friend, New York politician Andy Stein, with Bella in 1987.

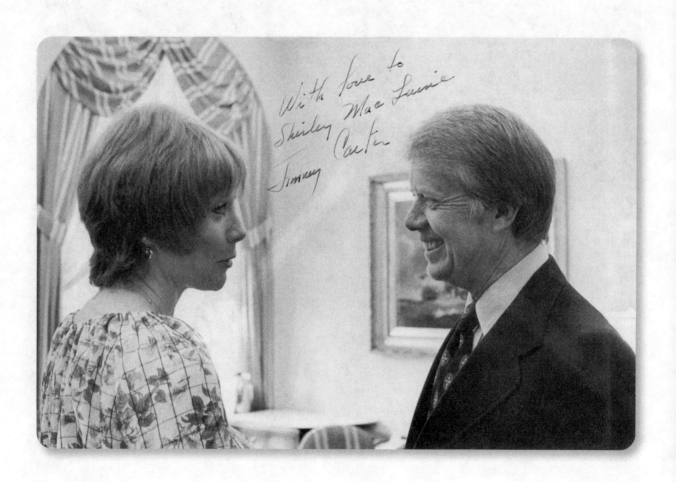

With love to
Shirley MacLaine
Jimmy Carter

By now I was a Democrat working for Jimmy Carter, loving his character and fascinated by his intelligence. He was a Southerner and proud of it, but also a dependable liberal. I was thrilled when he was elected in 1976. Starting with Harry S. Truman, I've actually met thirteen U.S. presidents. I never encountered Nixon; I thought he was ridiculous and wouldn't wanted to have met him. I actually liked Reagan as a person very much; he was a show business favorite. And back in probably the 1980s, I interacted with Donald Trump. I was at some function, and when he walked in, he saw me and straightened up. He started pulling at his tie, and I could tell immediately that in his mind he was starting to take off my clothes . . . and his. It was scary just how obvious he was being. He even figured out a way to try to stop me from leaving, but I had to get out of there.

Part 5

# *Hollywood, Part 2*

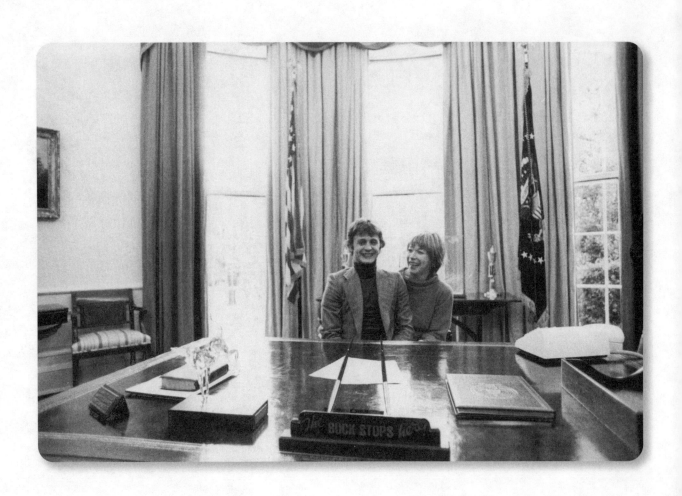

After five years, a great script brought me back to film. It was *The Turning Point*, written by Arthur Laurents, who was a pain in the butt but brilliant. Herbert Ross, the director, was an arrogant guy, very full of himself, but I adored his wife, the prima ballerina Nora Kaye. I'd seen her perform at Constitution Hall when I was a kid—she was one of the greats. During the making of the film, I became friends with Mikhail Baryshnikov. He was just fabulous and the best male dancer in the world. I remember him saying to me during a shoot, "I'd rather do *Swan Lake* thirteen times than wait for this scene to get lit." He got interested in my politics and wanted to sit in the Oval Office, so I took him to the White House and introduced him to the president.

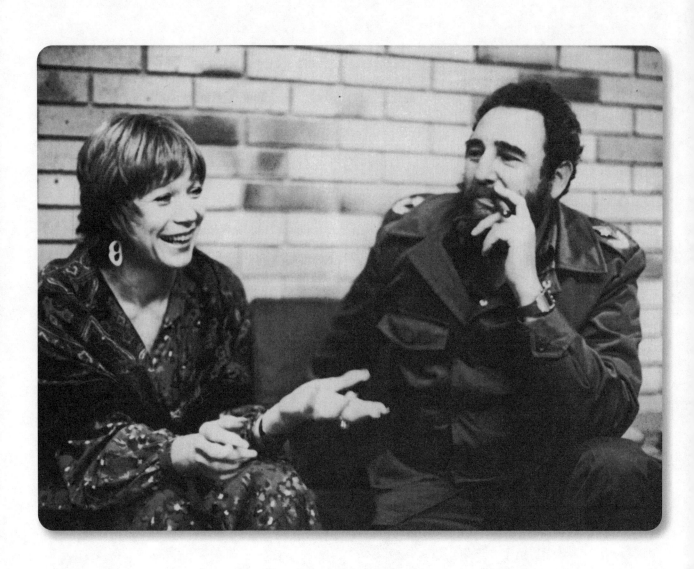

Fidel Castro and I had two days together. He was open, funny, and curious, especially about the Kennedys, and did not come on to me as Barbara Walters suggested he would. I admired his uniform, and he gave me one. When I returned home to New York, my maid unpacked it, saw it, and quit. She wasn't even Cuban.

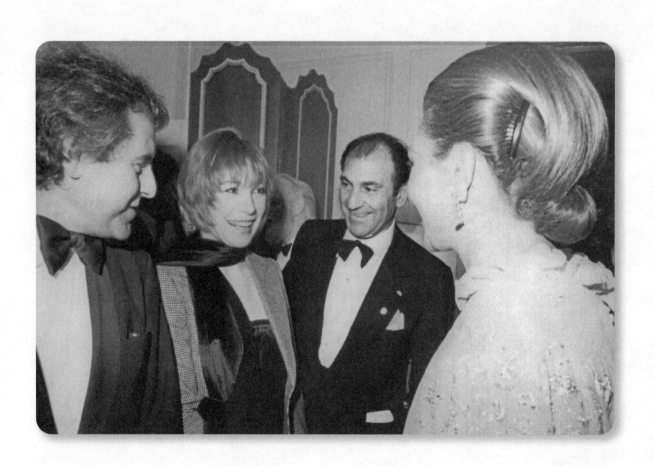

M eeting the shah of Iran with Miloš Forman in Europe. The shah wanted to meet more
movie stars, and after his exile, he did. He actually was instrumental in helping get me into
China with my female delegation.

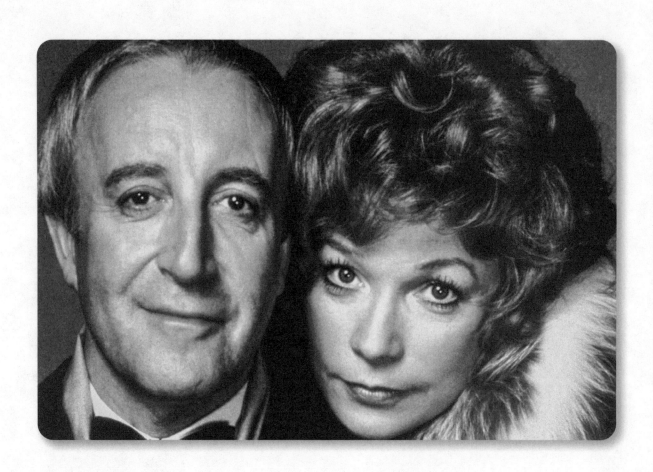

Peter Sellers and I worked together about ten years before *Being There* and had also been "jet stream pals." There was a rotating crew of actors who traveled together, flying to various Europe destinations for vacations, and I always enjoyed his company. As he was known to do, he completely disappeared into his character, Chauncey Gardner, on the set, even when the cameras weren't rolling. Between scenes, we barely spoke. I missed my old pal.

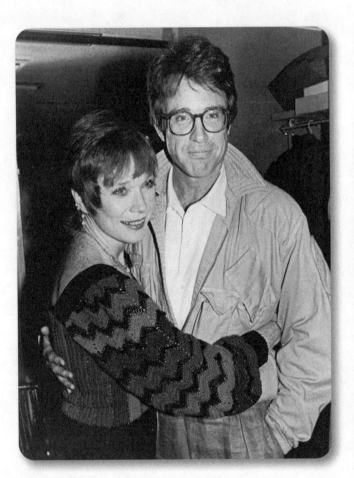
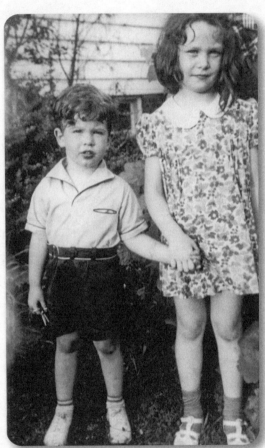

I never really talked to Warren about going into show business, except for one conversation we had when he was still back in Arlington in high school and I was in New York at P. J. Clarke's, standing there and talking with him on a payphone. He said he wasn't going to come to New York, and I gave him a long speech saying that he'd better—that he was talented and he knew what he was doing. I told him to try it, see what happens. Instead, he went to college but quit and *then* came to New York. We never talked about working together, except once when he was producing *Bonnie and Clyde*. They were going to offer me the role of Bonnie, but when it was decided that Warren was going to play Clyde, they got someone else for obvious reasons. This is one of the few photographs taken of us together.

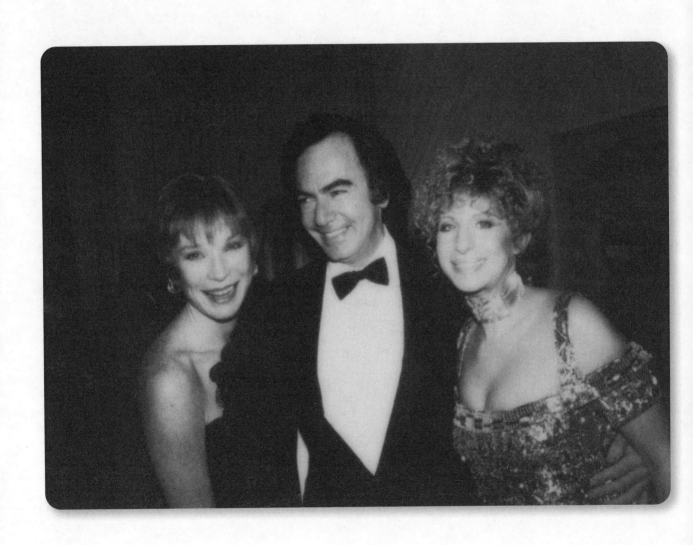

Barbra Streisand and Neil Diamond were doing a show together when I visited them. She and I were both born on April 24, and we always take time to talk on every birthday. We admire each other's honesty and our sense of "OK, let's get to the bottom of this." Her public persona matches perfectly with her private self. And of course, she's so effing talented.

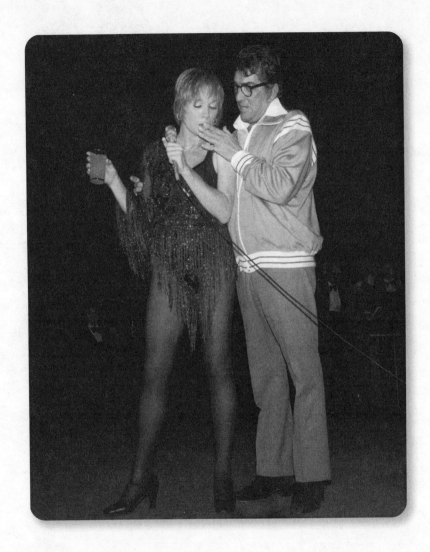

Dean loved to appear on *my* stage, interrupt, and try to throw me off by whispering dirty jokes in my ear. The crowd loved it. (By the way, I did eventually give up smoking when I was fifty.)

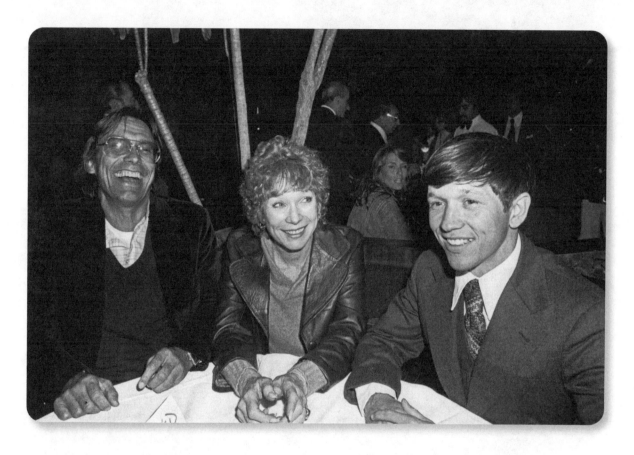

On the left is Russian director Andrei Konchalovsky. He is so talented and has a great sense of humor, but I helped him at the time with his Russian impatience. He left the Soviet Union to be with me, and we were lovers for a few years. On the right is Dennis Kucinich. I met him when he was the mayor of Cleveland, and he's been a friend for decades. I wish he would run for something and win.

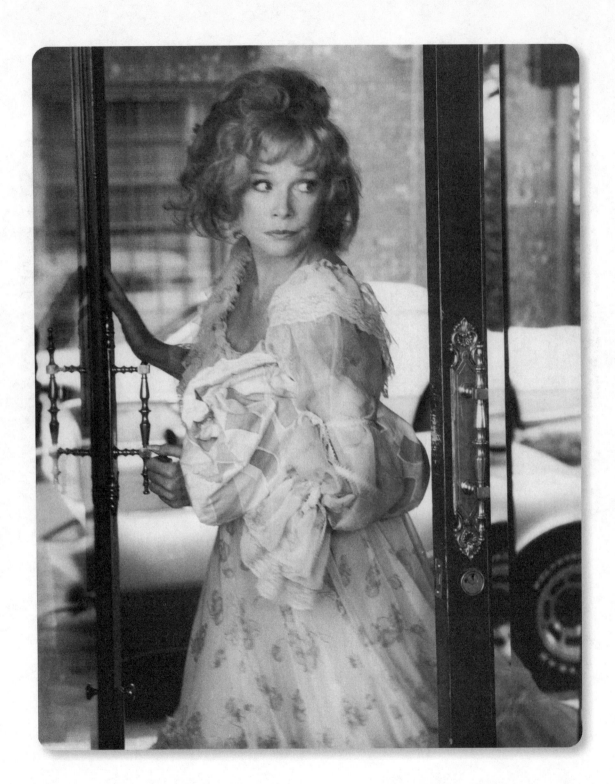

The script for *Terms of Endearment* wasn't finished when they sent something for me to read, but I loved what was there. And when it comes down to it—with the character of Aurora—I think I was playing myself. I did not enjoy Debra Winger. Also, my hair didn't always look like that; the top in the convertible was down before that scene.

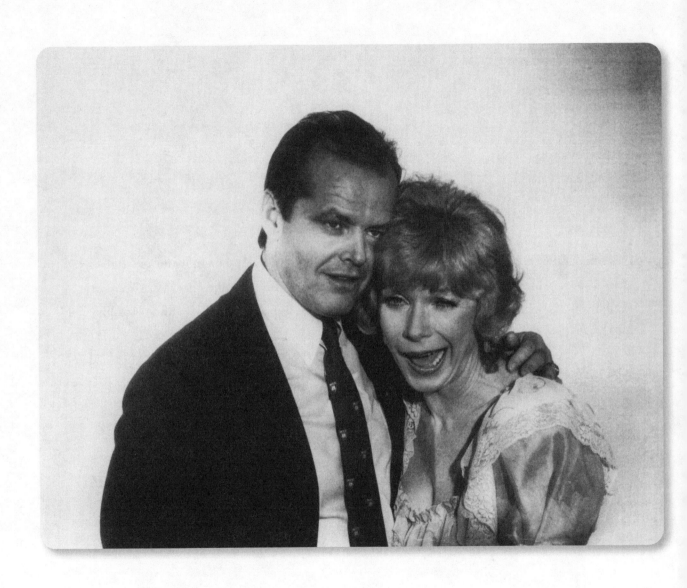

I might have met Jack Nicholson earlier because he's such a good friend of my brother's, but when I really got to know him was on the set of *Terms*. He was the best, my other favorite actor to work with. You never knew what he was going to do, but I was still confident in every scene with him.

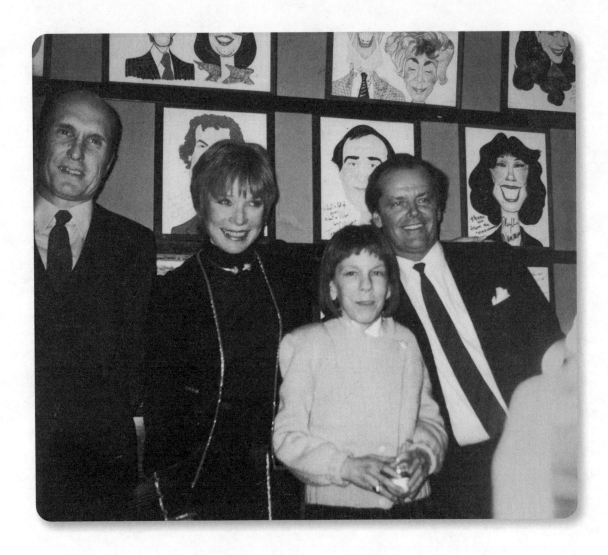

Here he is at the New York Film Critics Circle Awards . . . pinching my butt.

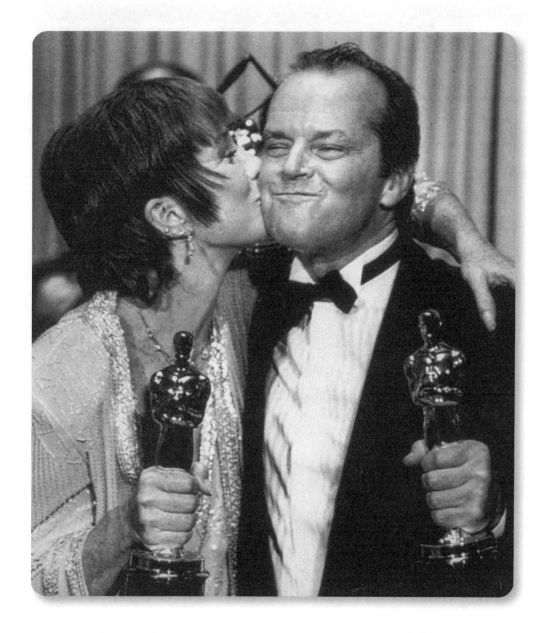

Perhaps you need offstage calamity in order to get an Oscar. In any case, I did deserve it. And when Jack and I won, he pinched my butt again.

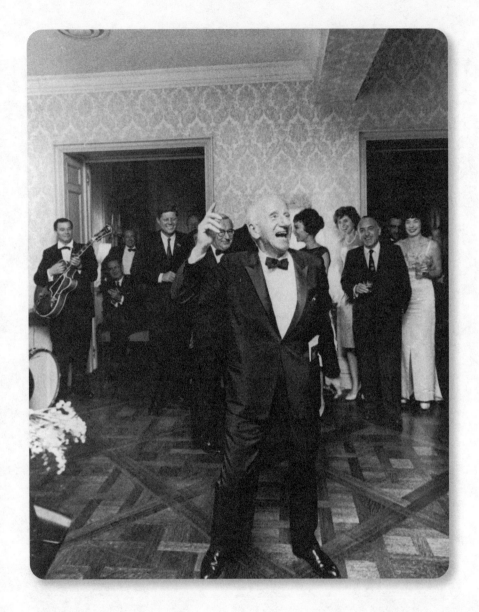

In 1962, at the famous celebration for John F. Kennedy's forty-fifth birthday at Madison Square Garden, Jimmy Durante and I performed for the president and the crowd, but what most people remember is Marilyn Monroe singing "Happy Birthday" to him. Afterward, there was a private party at Arthur Krim's home. In the above photo, Jack Kennedy had just walked out of the bedroom behind me, and Bobby Kennedy had just walked in. Marilyn was in the bedroom . . .

Here, I'm telling Teddy Kennedy that story in 1984 and he's laughing about how the boys got away with it all the time.

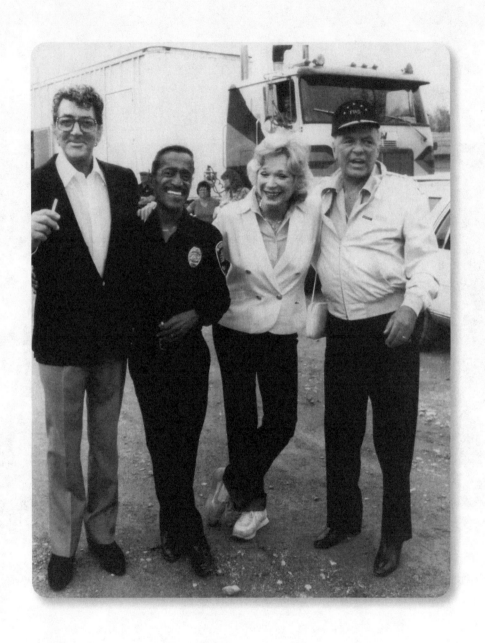

D ean, Sammy, me, and Frank on the set of *Cannonball Run II*. When some of us weren't working on the same film or project, we actually didn't spend a lot of time together, but we really did love one another.

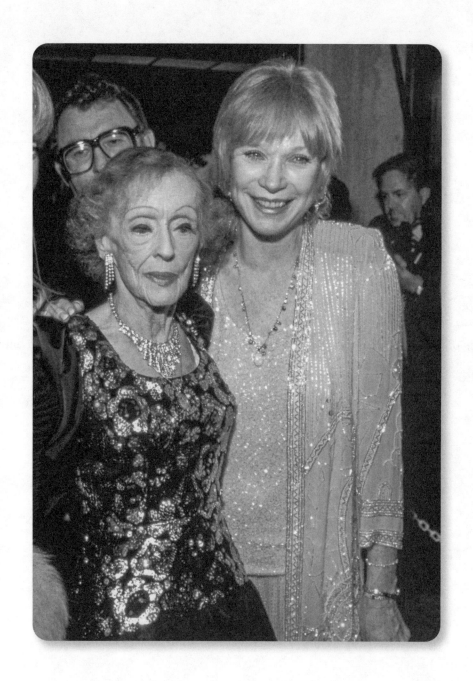

Me and Bette Davis at the 1986 Golden Globes. She was one of my favorite actresses and people. She was just clear with her expression, and everything she said was without pretense. I don't think I knew it at the time, but apparently she had wanted the part of Ouiser in *Steel Magnolias*.

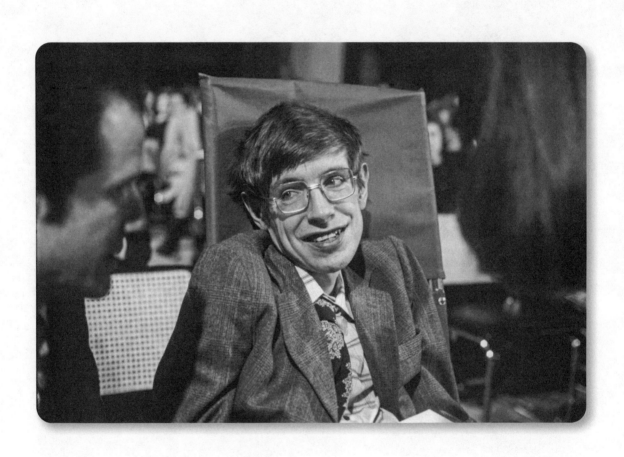

After filming *Madame Sousatzka* in London, I went to Cambridge University to meet Stephen Hawking, pictured here on campus. We talked for hours—asking each other astro-theoretical questions. He once said to me, "If you think I don't believe in God, then you don't know me." Whenever Stephen traveled to America, he always called and I would give him a party. I believe he came to me because we would discuss his feelings.

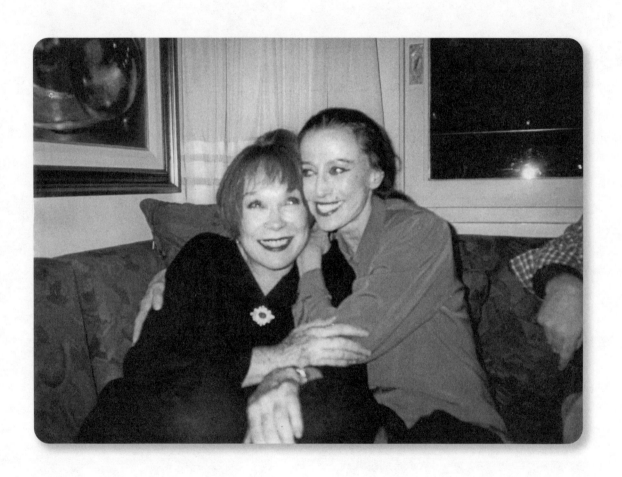

Maya Plisetskaya, the best ballerina in the world, with me in my apartment in New York. We would talk ballet all day. I met her through my brother and reminisced that as you got older, dance meant everything.

Colin Higgins is a brilliant writer of screenplays and a very talented director. Here we were in Peru in the Andes shooting *Out on a Limb*, the TV miniseries adaptation of my memoir where I more publicly established my journey into spirituality and past lives. But I was never nervous about being open about any of that; people came up to me regularly and said the book changed their life, knowing that someone else thought the same way or believed the same truth. But I didn't write it for that reason; I did it for myself. By the way, when Colin and I were in the Andes, we waited for UFOs. None came. We still wait and believe.

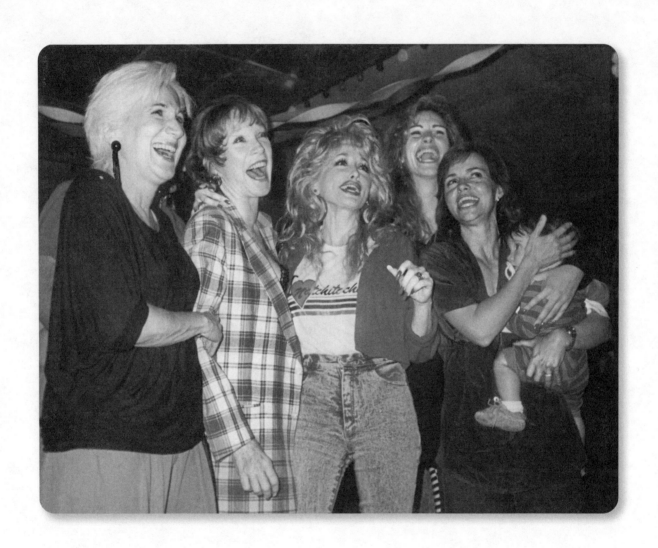

We loved one another . . . but not the director. The director of *Steel Magnolias* could be very cruel to Julia and would just say every now and then to Dolly, "Why don't you take an acting lesson?" But she was absolutely herself and was not playing a role. Herbert Ross actually offered me first choice of any role except Shelby and M'Lynn, and Ouiser is what I wanted. And on set, there were times when he inspired me to become Ouiser.

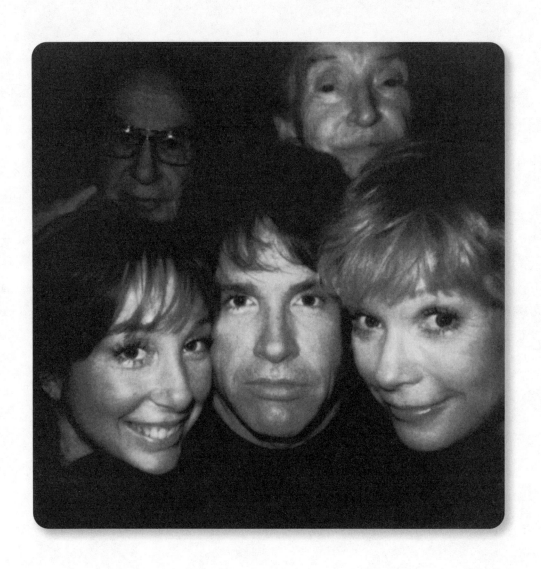

Warren's first directorial still picture, featuring our parents and Sachi.

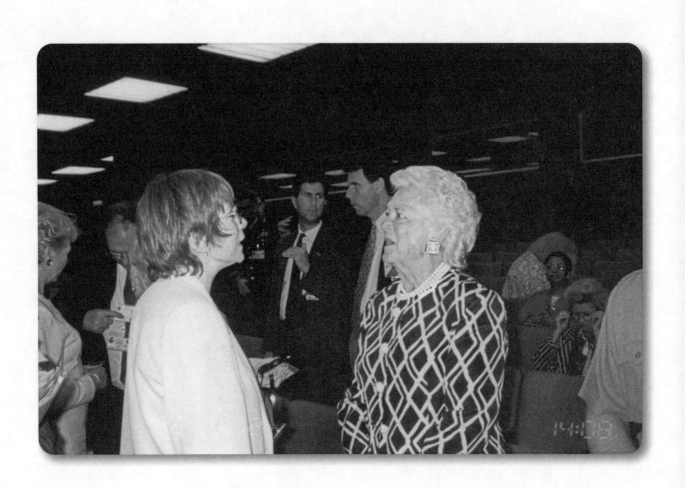

Speaking with Barbara Bush at a fundraiser. She told me she meditated to my chakra poster. She admired the science of spirituality. She was one of the nicest Republicans I ever met.

# Part 6

# *New Adventures*

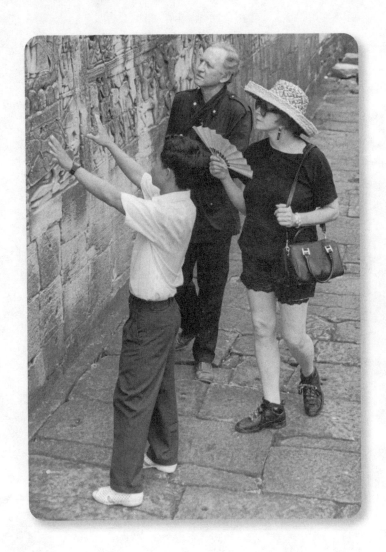

With my good friend Andrew Peacock in Cambodia.

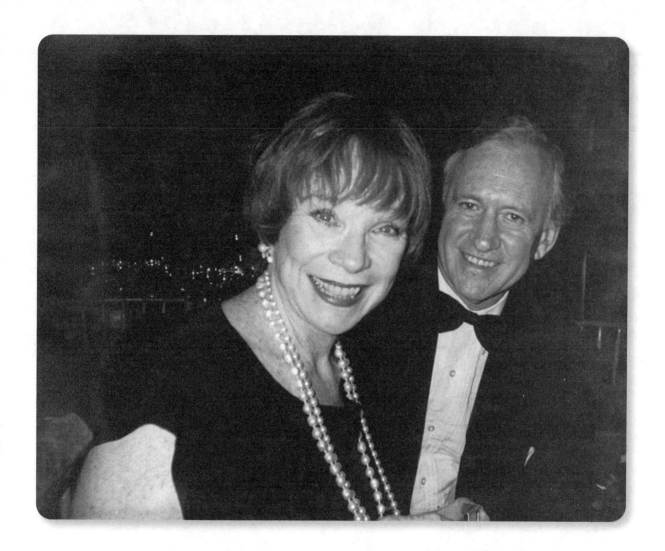

We met and traveled the world together. Steve was in Japan working, and he understood.

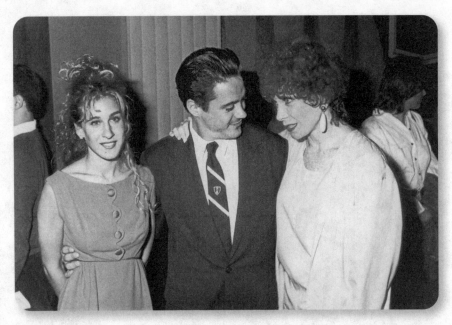

Robert Downey Jr. and Sarah Jessica Parker when they were together.

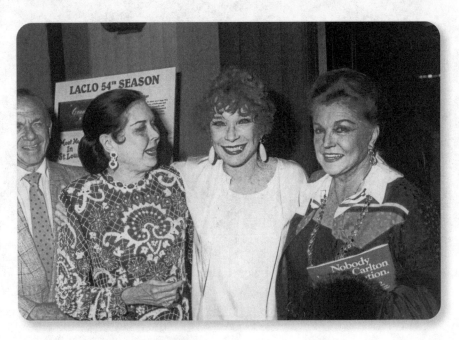

Ann Miller and Esther Williams. They sang, danced, and swam. (At least Esther swam.)

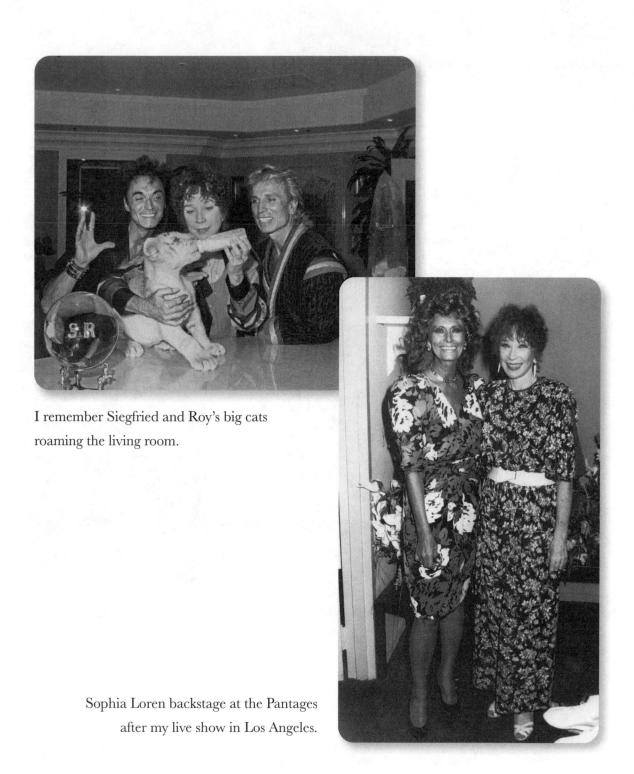

I remember Siegfried and Roy's big cats
roaming the living room.

Sophia Loren backstage at the Pantages
after my live show in Los Angeles.

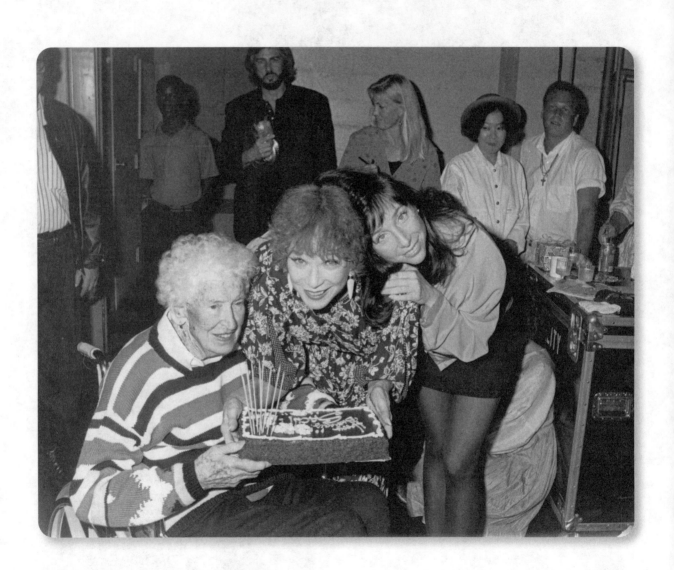

There are three generations of MacLean-Beatys in this photograph.
We took this one on Sachi's birthday.

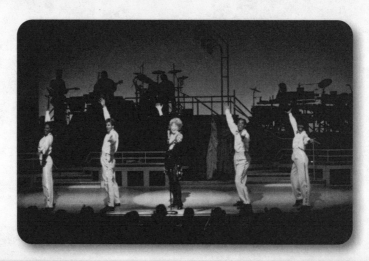

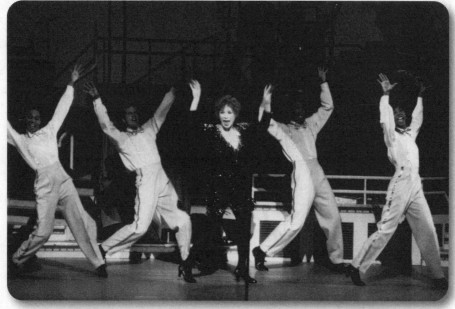

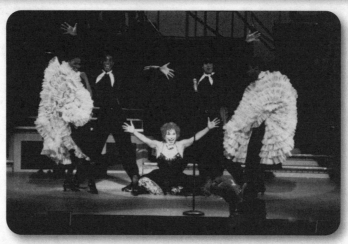

Being onstage was my favorite and the most daunting form of expression. When it was working, I enjoyed it more than acting for film. In a live performance, you can't be anything but ready. On my shows, we'd have a choreographer to work with, and I'd pick the songs, which were somehow related to my life. And in these photos are the four cast members who traveled with me in the early '90s. I appreciated everything they went through individually; they were family. They were also better dancers than I was.

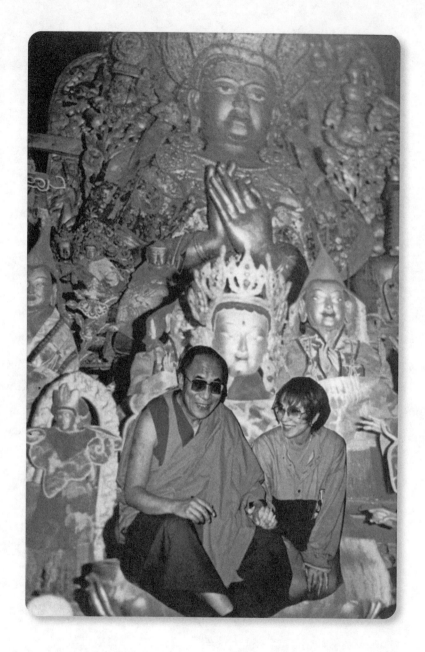

Here I am with the Dalai Lama at the 1992 Earth Summit in Brazil.

He is a man who knows himself and his role in the world.

His sense of humor is childlike and broad. I wondered what he did for sex.

I've spent hours with the Dalai Lama—sometimes talking, sometimes just being. The "beingness" resonated with me; then I thought of the laws of karma and how what we put out returns to us from lifetime to lifetime. I wondered how long it would be before we could find ways to verify the evolution of the soul in the same way that they had verified the evolution of the body.

I thought about all the books I have read to try and understand quantum physics, "the new physics" they called it. But quantum physics sounded a lot like ancient Eastern mysticism. A few quantum physicists were saying that it looked as though some subatomic particles actually possessed a consciousness. With photons, for example, physicists observed "reality" whereby activity seemed to be occurring on as many as twelve different dimensions simultaneously. "Everything" is occurring at the same time. Ancient Hindu wisdom claims the same thing. The new physicists were saying that the key to understanding the universe was in understanding ourselves, for we alter the objects we observe simply by observing them. Therefore, science and quantum physics leads us only to one place: ourselves. The dance and the dancer are one.

The Dalai Lama is a yogi who learned to raise his own consciousness to see his past-life experiences as well as the experiences of others. I wondered what he was seeing as we sat together. Enlightenment was a state of being. So to be open-minded was the first step toward enlightenment.

I thought of the great thinker and scientist Giordano Bruno. He was burned at the stake because he envisioned multidimensional solar systems, saw parallel planets to ours, envisioned life on other worlds, and publicly stated what he believed.

I remembered the Lama-priests I had seen in Bhutan. In subzero weather they came to a frozen lake, submerged themselves in a hole cut into the ice, and meditated until the ice around them melted and steam rose from their bodies. They explained that they had simply raised their vibrational frequencies; the faster they accelerated their frequencies, the closer they approached the divine force. They saw this as white light.

I was sitting with a human being who had probably achieved these higher levels of consciousness. I understood him intuitively but not intellectually.

He sat silently but then very subtly took a sip out of a glass that he had been hiding. I wondered what was in it.

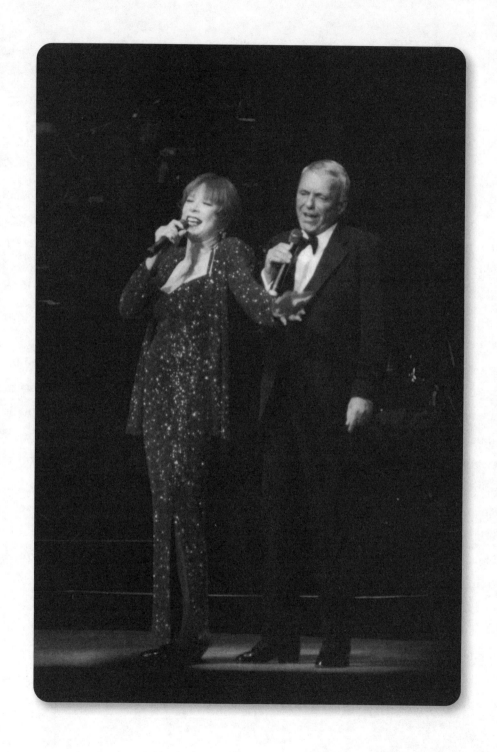

Sometimes I opened for Frank and would step in front of his cue cards so he couldn't read his lyrics! In later years, his memory might not have been as strong, but his work ethic definitely was, and he respected the past more. And he always had his sense of self. I remember back when Frank was dating Juliet Prowse—and not long after we all worked on *Can-Can* together—he and I were at a bar having a drink and I was telling him that Juliet was too young for him, but he didn't think that was an issue. What he didn't like was that she wanted him to meet her parents and basically pass muster with them. His response: "I don't pass muster with anybody."

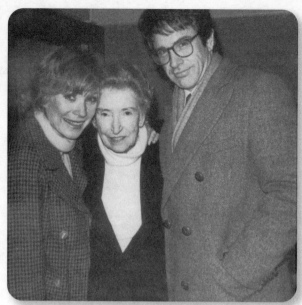

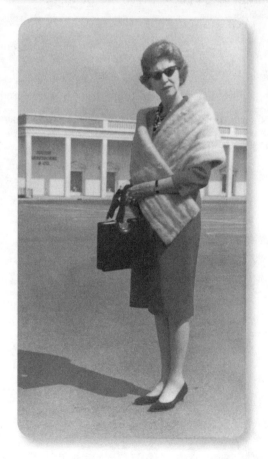

As I look back on it, I realize that my parents often left me alone but were there for me when I needed them. Maybe not so much as examples but more for support. I think that was a huge lesson. They let me travel to Washington almost every day by myself for dance lessons and go to New York alone at sixteen to perform. I thank them so much for how they raised me. Because of that, I am so secure in my independence and have had so much freedom. It's amazing.

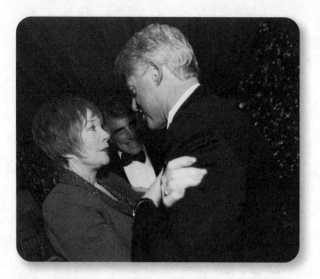

Bill Clinton and I had a long, long walk on the beach.

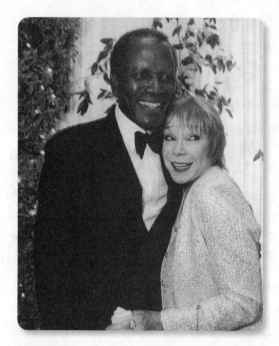

With Sidney Poitier at his 1992 AFI Life Achievement Award ceremony. I had a crush on him. He was a very nice friend.

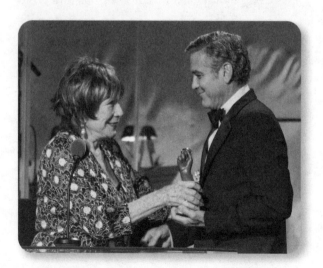

George Clooney. The sweetest flirt—I know! Here I'm presenting him with the Brass Ring Award at the Carousel of Hope Ball.

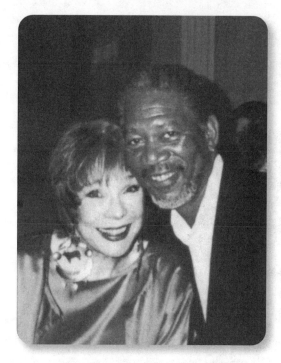

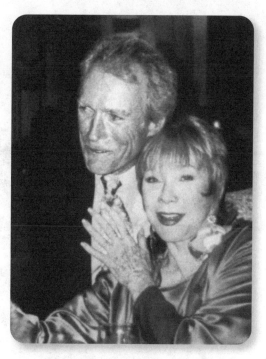

Morgan Freeman. I propositioned him and he turned me down.

Clint Eastwood: the nicest and most professional actor in the world.

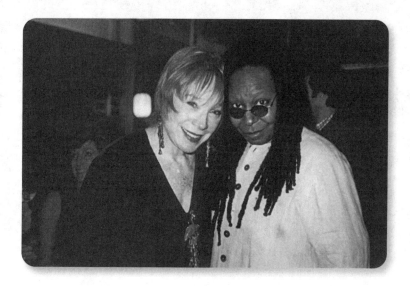

Whoopi Goldberg and I always talked metaphysics. She tells the truth.

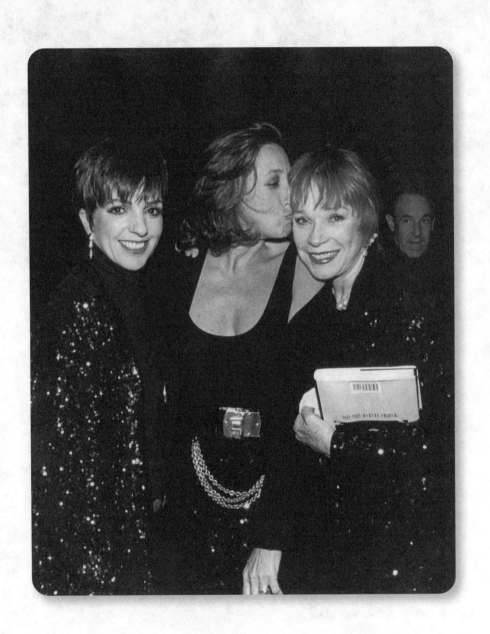

Donna Karan used to make sparkling outfits for Liza Minnelli and me. Here we are in a couple of her creations at the opening night of a Martha Graham dance performance in New York in 1992. Liza was a very close friend. I first met her when she was probably about twelve years old. Her father was directing me in *Some Came Running* and he brought Liza over to my house, where she did a little show for me. She was so talented, even then. And what a film *Cabaret* was! I guess Bob Fosse had gotten his practice on *Sweet Charity*.

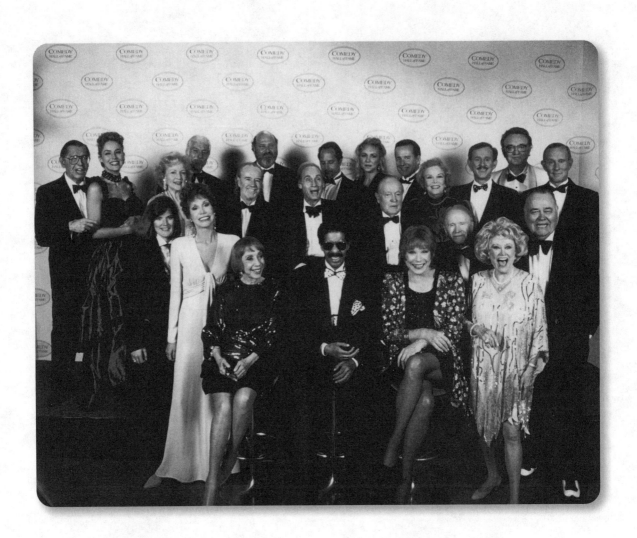

In 1994, I was inducted into the Comedy Hall of Fame along with people like Bob Hope, Milton Berle, Mary Tyler Moore, and Richard Pryor. It's funny, because I don't consider myself funny. But I can be . . .

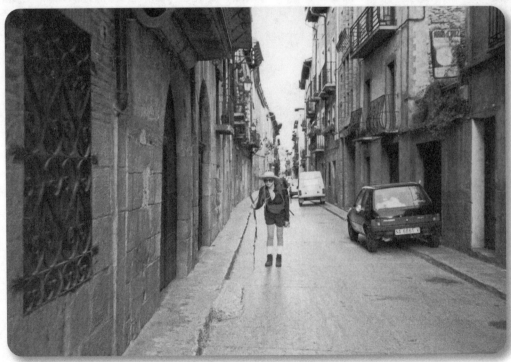

In 1994, I walked the Camino de Santiago, a five-hundred-mile trek across Spain, in thirty days by myself. The Camino was one of the most fulfilling journeys I've ever taken. I was completely alone, day and night, and I turned sixty while walking. I discovered things about myself by being alone that I never imagined. I wrote *The Camino* when I returned—recommended reading. But travel has always been one of the most important things in life to me. I think I made movies just to pay for airplane tickets. I couldn't *not* travel, because I met so many people and saw so many different indigenous cultures and heard so many different points of view on great big subjects like life and death, sickness and health, and male and female. And I had to learn what all these different species on Earth were doing or attempting to do. I've been nearly everywhere except for one place: New Zealand. Among all my travels, my favorite place is Africa, specifically Kenya, with the animals. I once went on a safari, and a man threatened to kill a leopard. I threatened to kill him. I remember the mother leopard and her cub. I watched every moment of their exchange. I said goodbye to all of them. Sometimes I think that I want to die at an old age watching the giant animals living peacefully together . . . and people, too.

A little inside humor between me and Colin Higgins about our creative process.

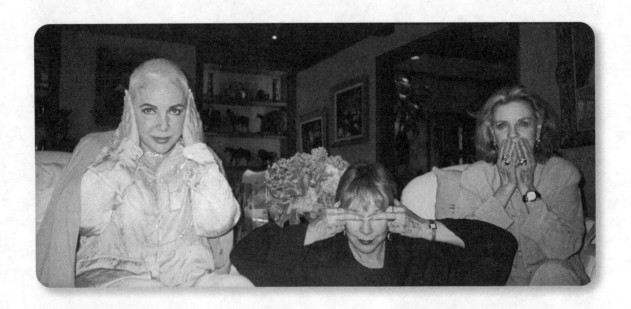

We told each other everything—Elizabeth, Betty Bacall, and me . . . and then posed. I call this one the "see, speak, and hear no evil" picture. Elizabeth had just had brain surgery and we were with her at her place with some other good friends.

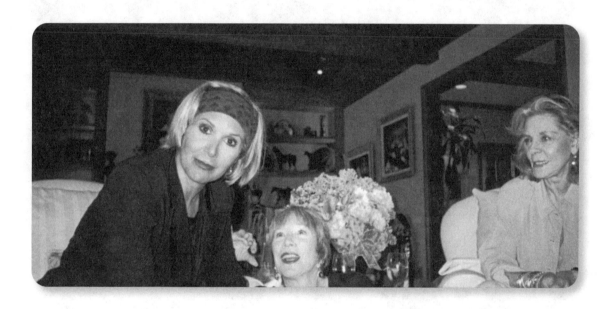

Carrie Fisher was there that day, too. She was funny! But anybody who's the daughter of Debbie Reynolds and Eddie Fisher had better be funny. Imagine having those parents!

I had Sachi when I was only twenty-two, so when we were younger, as I wrote earlier, it almost felt more like we were sisters. Now that we've both got some years behind us, it really is that way. We talk together on the phone like two old ladies and are closer than we've ever been.

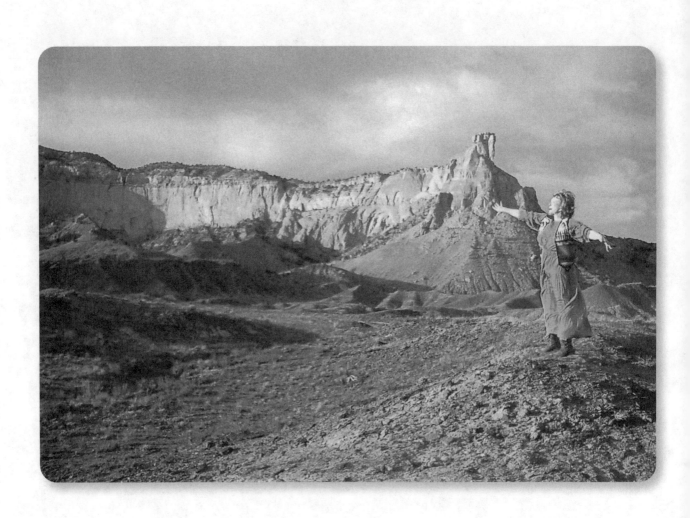

My first day in New Mexico, in 1993. Santa Fe and Abiquiu are the two spiritual capitals of the country to me. They are my primary residences and they are where I write. New Mexico speaks to me because it is a place that is still on a search for itself; everybody else there is, too. Everyone seems to be in the same "church." There's something hidden in the hills, something hidden in the ground. (Actually, crystals are everywhere, and that's what attracts the UFOs.) It's funny how when you're in a search for yourself, you're not quite home yet. So when I'm at my place in California, I'm not searching; I just enjoy the now. New Mexico, though, is still a search.

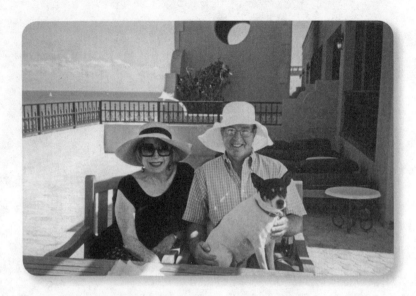

Ed Mitchell, the sixth man to walk on the moon, in 1972, also shares my interest in UFOs. I'd been intrigued by the concept of extraterrestrial life since I was a kid. I just didn't talk about it with anyone for years, probably not until I moved to New Mexico, where it's an open secret.

On the right, my friend Johnny Mack, who had many patients who went aboard ET crafts, and the experience changed their lives.

Me with Mother (in the middle) and Anne Marie, who ran the Ashram, a spiritual bootcamp in the hills of Malibu. She was my best friend and had an ability to make the subjective and the spiritual understandable.

On the day this photo was taken, Carlos Menem, the president of Argentina, questioned me on what I knew regarding UFOs, and we talked for hours about them. He had no doubt about their existence and said he was deeply in touch with his military about their reality.

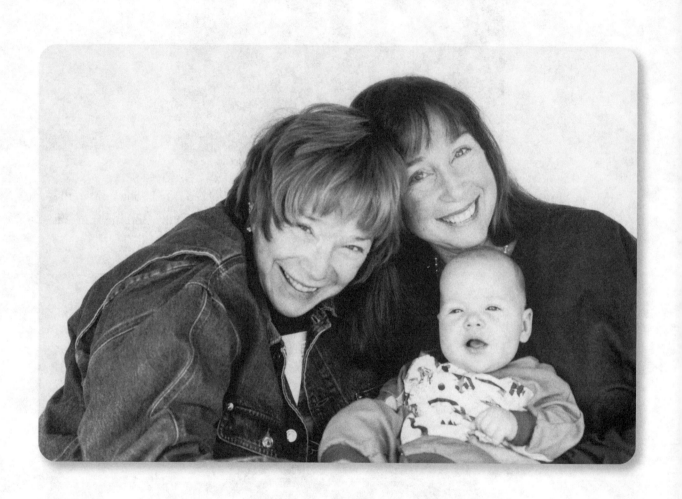

When Sachi became a mom, I became a grandma. I loved it but had to really start remembering dates and presents. Her kids are in their middle and late twenties now.

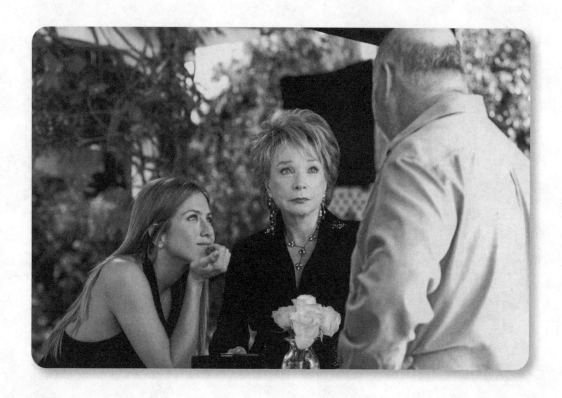

In 2005, I costarred in the movie *Rumor Has It*. Jennifer Aniston was a real professional. She asked me many questions about everything. She's more down-to-earth than her position in the business would have you think. She's a real star, but also a real person. She "gets it." Rob Reiner, with us here on set, is a great comedy director, and it makes sense; he came from a background of comedic acting, as well as a background of two professionally humorous parents.

Kevin Costner was very funny on the set . . . and a big flirt.

I'm proud to say that I was responsible for bringing Michael Caine to the United States to do the film *Gambit* in 1966. We had great chemistry in it probably because he's got a great sense of humor and is just a wonderful man. We've been friends ever since. Almost forty years later, we reunited for *Bewitched*. I love this picture because it shows how fun and easy it was to be around him.

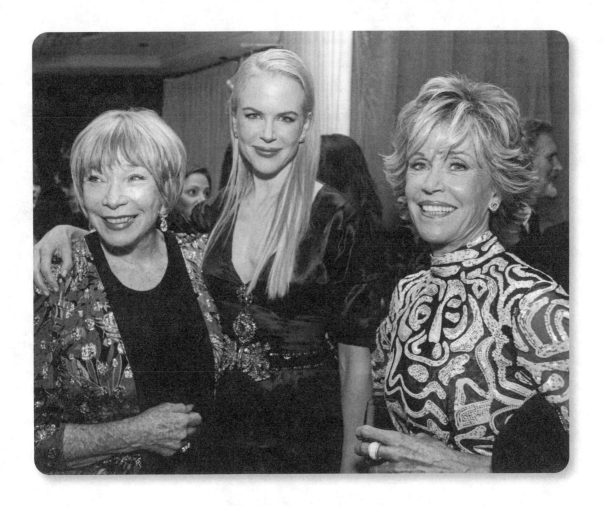

Me, Nicole Kidman, and Jane Fonda at *Elle*'s fifteenth annual Women in Hollywood Tribute in L.A., 2008. Two very nice people and two brilliant actresses.

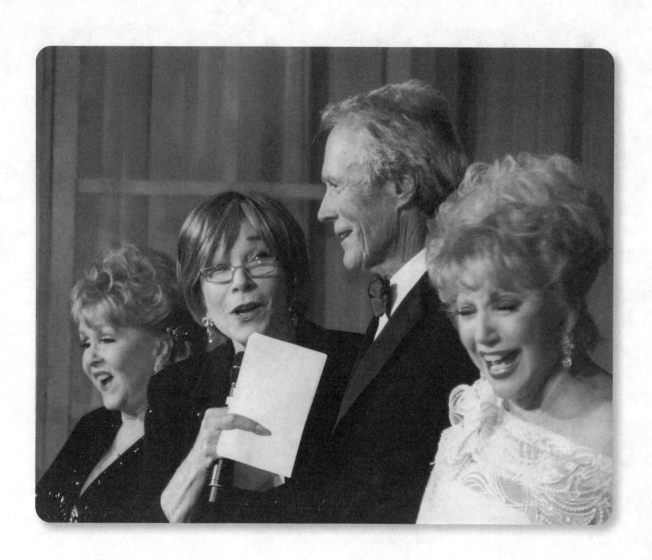

D ebbie Reynolds, me, Clint, and Ruta Lee at the Thalians Gala in 2008 to raise money for mental-health-related causes. I presented Clint with the Mr. Wonderful Award. Debbie ran things, and Clint finally got us all off the stage so he could speak.

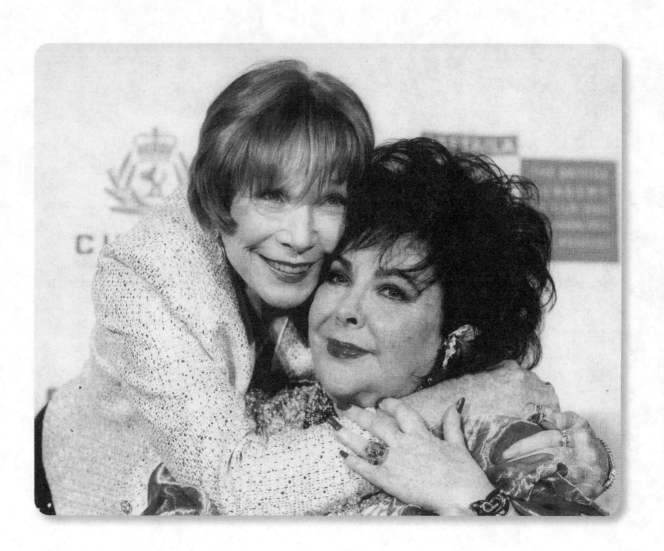

Elizabeth Taylor was the most kind and generous of all the actresses I've known. And smart and funny and honest and unpretentious and courageous. And insightful about people. She was the best of everything—she really was. She and I found a deep and trusting relationship, and she was my best friend. I actually introduced her to her husband Mike Todd, who produced my *Around the World in 80 Days* experience. The day Todd died in an airplane crash I went to her house immediately. We sat and cry-talked all day; she was in the tub drinking cocktails and I was trying to sit up straight in a chair beside her, attempting to keep count. She was devastated. Often in later years, when she visited me at my apartment at the beach, she got down on the floors and cleaned them and said, "All I want to do is be a housewife." I think that sentiment was real.

I had known Maggie Smith for about twenty years before we did *Downton Abbey* together, and I always reminded her, "I'm older than you." We sat around in our period costumes, hair, and makeup, and talked about life. (I'm glad it was winter, because the costumes were very tight.) Sometimes in between scenes, I would watch her in a tiny rehearsal room playing cards by herself. It was an entertainment for me just to watch how this brilliant actress reacted to winning, to losing, to luck. More than anybody else, she doesn't cover up. She's something else.

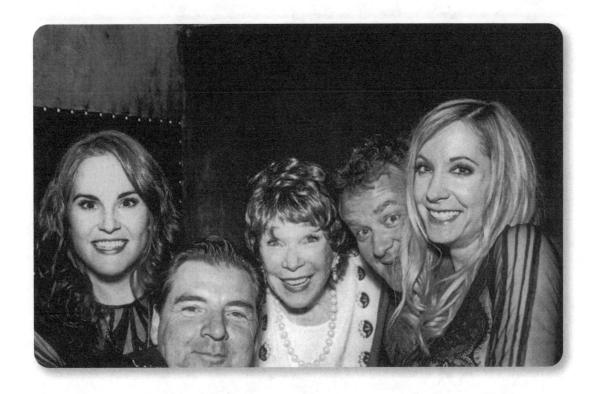

Michelle Dockery, Brendan Coyle, Hugh Bonneville, Joanne Froggatt, and me out of our *Downton* looks.

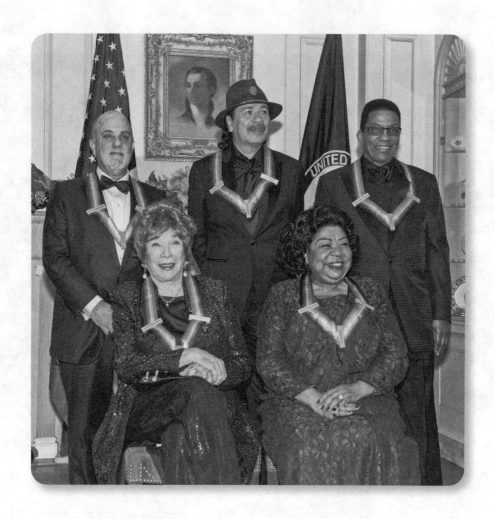

In 2013, I was awarded a Kennedy Center Honor, along with Billy Joel, Carlos Santana, Herbie Hancock, and Martina Arroyo. I thought, *Good idea*.

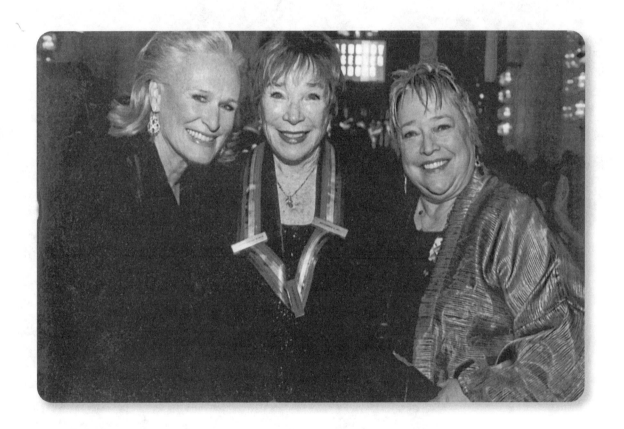

Glenn Close and Kathy Bates came across the country to be with me for the event.

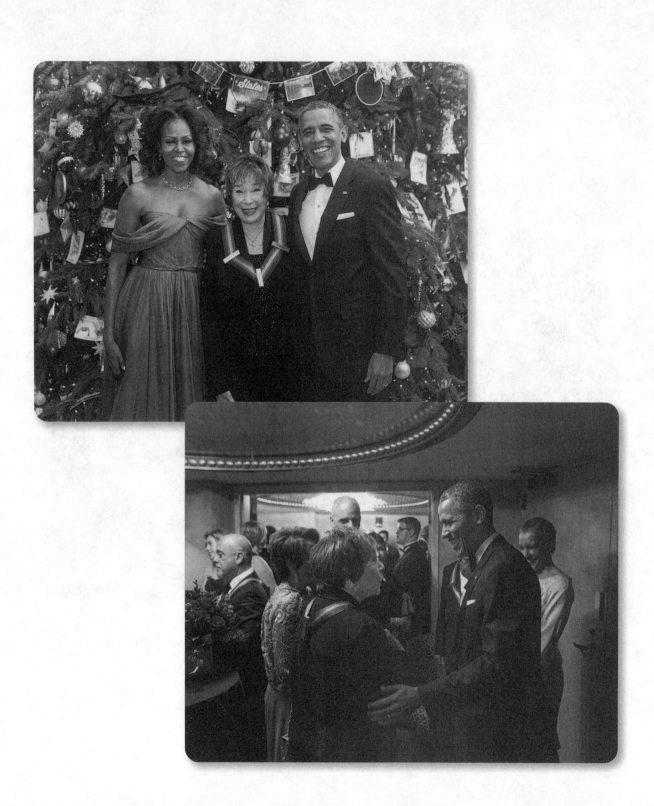

President Obama—he's a nice guy and very smart. He made jokes about me and extraterrestrial life—good ones. Officially, though, he was quiet on the subject of UFOs.

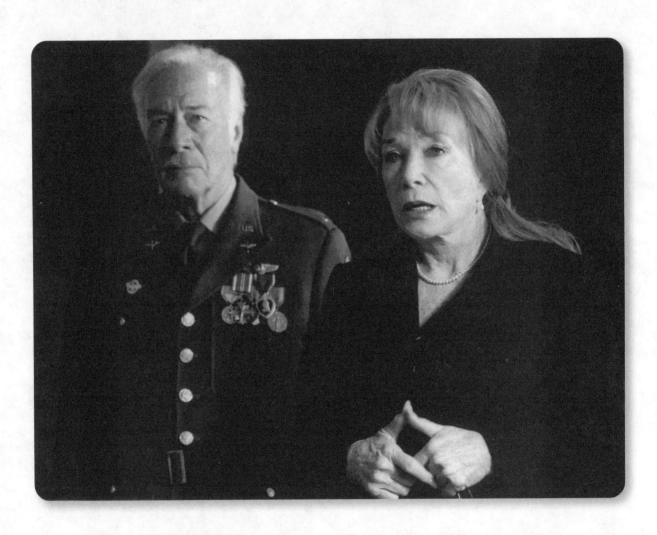

With Christopher Plummer on the set of *Elsa & Fred*. I loved working with him.

Over the years, when I've said yes to a film, it's because I feel like the role that's been offered represents a character that is really part of me. I look for it in myself, so I don't have to pretend, which I hate doing. I could never do what Meryl does—that intensity. I think I've known my limitations and obeyed them. And I've turned down roles where I didn't feel like "going there."

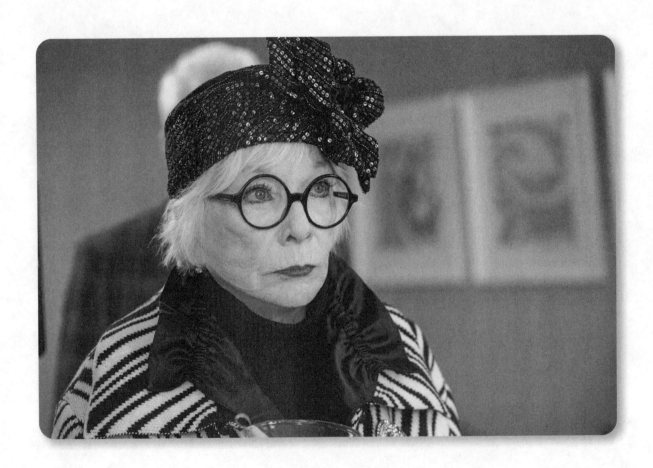

*O*nly *Murders in the Building* was fun. I'd known Steve and Marty for years but got a real kick out of shaping the wardrobe for my character, Leonora. Sticking to a strict black and white color scheme was my idea.

Part 7

# Looking Back—and Ahead

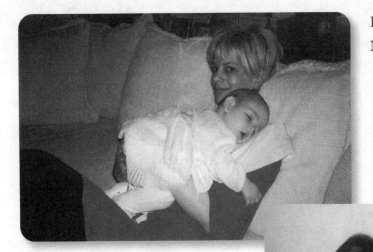

Laura Lizer, my business manager.
Now I'm godmother to her son.

Mort Viner, my beloved agent,
was with me for thirty-five years . . .
I probably killed him.

Peter Levine, my new beloved agent,
who I hope will be with me for
another thirty-five years. (I just hope
I don't kill him.)

The agents and managers I've surrounded myself with live up to my trustworthiness and esteem and don't pussyfoot around—that's why I stay with them.

George Huvos, my first love, and Andrew Peacock, my last love. There were also relationships with Pete Hamill and Sander Vanocur, two journalists, interestingly, and I lived with both of them (separately, of course). I've been curious with each of these men: What makes them what they are? Who are they? What are they doing? What have they decided about their lives? These men were wonderful to me, and I cherish the time I spent with them. But I never saw a future with any of these guys except Steve. It was enough to have an affair. And it wasn't deceitful. Everyone was aware of the situation. When I was campaigning for McGovern in 1972, *Newsweek* magazine brought up my open marriage in an article, but other than that I rarely got questions on the subject. Maybe it was the way I conducted myself. And it never occurred to me to worry about what people thought; I was leading my life the way I wanted to.

Admiring Annette and Warren's firstborn.

Warren is a very devoted husband, father, and head of family.

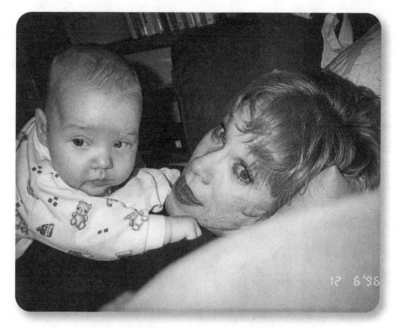

Warren and Annette's budding family.

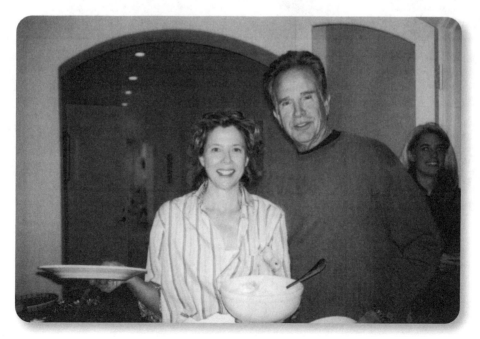

Mother cooking.

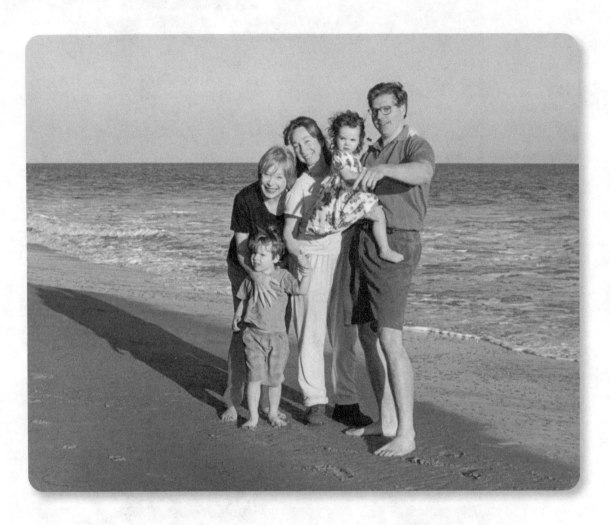

Sachi; her husband, Frank; me; and her children.

Today, my grandchildren are all grown up, and I've enjoyed watching them become, well, *themselves*. I wonder what this world will hold for them.

My favorite dog, Caesar.
I've had dogs my whole life
and never want to be without
one, but he was the original.

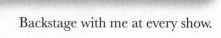

Backstage with me at every show.

Trixie and Terry—
my favorite dogs now.

There's so much I love about dogs. Their fairness, their prove-it-to-me attitude, their protection, their cuddliness, their company, and their humor. The original Terry and the current incarnation of Terry have both been the funniest of all my dogs. They're just so human that they're funny. And like me, dogs love trying to figure out people.

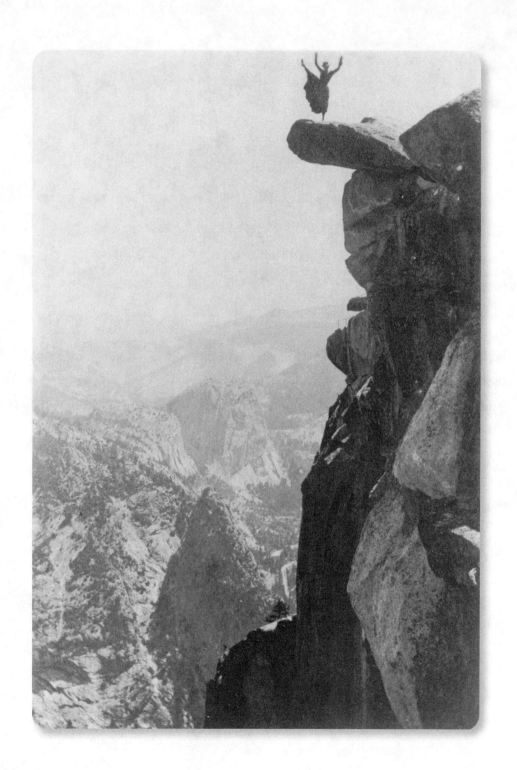

This picture is of me dancing on a cliff . . . or maybe it's not me. I honestly don't remember, but I do know that I love this photo, and if nothing else, it does express how I've lived my life. I was free and I was in love with risk-taking. And one of the biggest risks, given my character, was marriage. That was risking freedom, but I was protected from losing it by a man who understood (and was taking big risks himself all the time). I risked danger regularly with all of my solo travels around the world. I was risking proper alignment of my body with all the punishing dancing I did from a very young age. I was risking aloneness in my unconventional approach to relationships and motherhood. I risked balance—or maybe more accurately, people's perception of my balance—with my beliefs and interests in unconventional and spiritual realms. And I risked being photographed and being filmed, which if you allow it often enough, and over many years, can do things to your head if you're not careful. And if you combine all these factors, yes, maybe I did risk being on the edge. But I always knew I would be fine. And the things you can see from that vantage point . . . When it's time to really step off that cliff, I'm not afraid. In a way, I'm looking forward to dying, so I can see what it's all about and make some decisions about what kind of experience I can learn from next. It might not even be on this planet, and I think I would want to try a completely different existence. So I'm not sad or scared that this life is ending at all; I've always loved to travel.

## PHOTOGRAPH CREDITS

*All photos are printed as courtesy of the author unless otherwise noted here:*

Page 157: Snap/Shutterstock

Page 158: Gibson Moss/Alamy Stock Photo

Page 159: Archive Photos/Getty Images

Page 162: MediaPunch, Inc./Alamy Stock Photo

Page 164: Santi Visalli/Contributor/Getty Images

Page 178: Doug Niven

Page 180: Alex Berliner

Page 192 (*bottom left*): Christopher Polk/Staff/Getty Images

Page 215: Jess Vespa/Contributor/Getty Images

Page 222: Pool/Pool/Getty Images

Page 228: Album/Alamy Stock Photo

Page 232 (*bottom*): John Salangsang/Shutterstock

# ACKNOWLEDGMENTS

Thank you to my editor, Matt Inman, at Crown, as well as David Cashion at Kevin Anderson & Associates, for helping me to turn my Wall of Life into the book of photographs and stories you now find in your hands.

## ABOUT THE AUTHOR

Shirley MacLaine is an actress, an author, and a former dancer. Known for her portrayals of quirky, strong-willed, and eccentric women, she has received numerous accolades over her seven-decade career, including an Academy Award, an Emmy Award, six Golden Globes, and an American Film Institute Life Achievement Award. Apart from acting, MacLaine has written numerous books on the subjects of metaphysics, spirituality, and reincarnation, as well as a *New York Times* bestselling memoir, *Out on a Limb*.

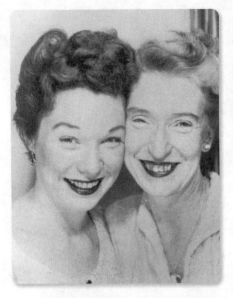
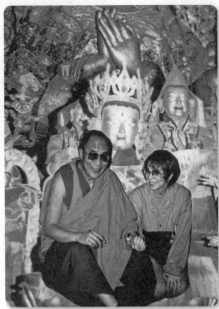
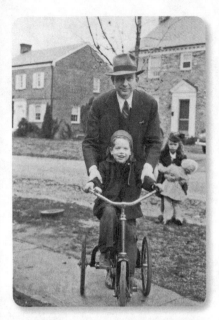

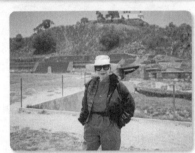
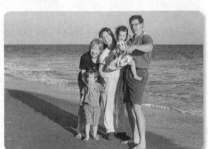

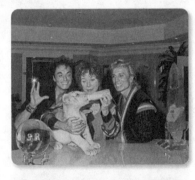

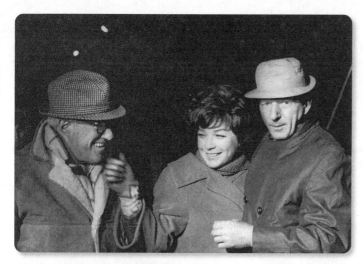

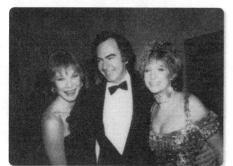

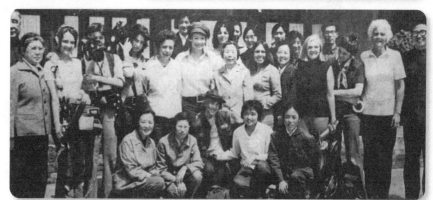

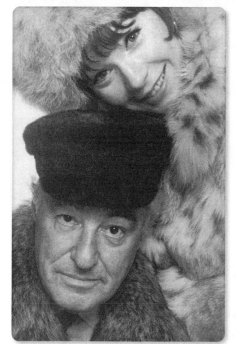

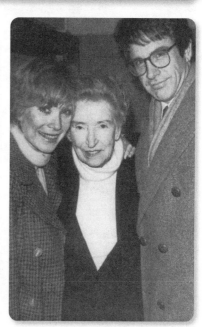

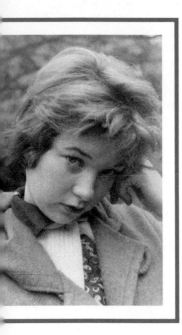

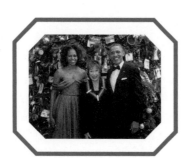

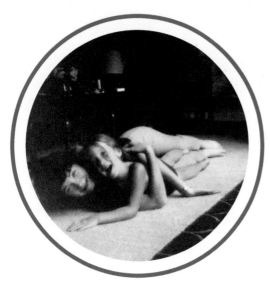

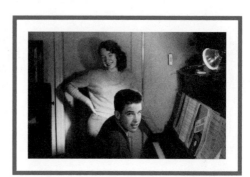